JAMES MCNEILL WHISTLER

LISA N. PETERS

SMITHMARK

This edition published in 1996 by
SMITHMARK Publishers, a division of U.S. Media Holdings, Inc.,
16 East 32nd Street, New York, NY 10016.

SMITHMARK books are available for bulk purchase for sales promotion and premium use.
For details write or call the manager of special sales,
SMITHMARK Publishers,
16 East 32nd Street, New York, NY 10016;
(212) 532-6600.

This book was designed and produced by
Todtri Productions Limited
P.O. Box 572, New York, NY 10116-0572
FAX: (212) 279-1241

Printed and bound in Singapore

Library of Congress Catalog Card Number 96-68021

ISBN 0-7651-9961-0

Author: Lisa N. Peters

Publisher: Robert M. Tod
Editorial Director: Elizabeth Loonan
Book Designer: Mark Weinberg
Production Coordinator: Heather Weigel
Senior Editor: Edward Douglas
Project Editor: Cynthia Sternau
Assistant Editor: Linda Greer
Picture Reseacher: Laura Wyss
Typesetting: Command-O, NYC

PICTURE CREDITS

CONTENTS

INTRODUCTION:
A BUTTERFLY WITH
A SCORPION'S STING

*A*n American-born artist who remained an expatriate throughout most of his life, James McNeill Whistler was one of the most original and influential artists of his time. He was a leading figure in the aesthetic movement in America and Europe and an innovator whose quasi-abstract works and experimental techniques had a profound impact on the artists of his era. Whistler's tremendous contribution was acknowledged in 1907 by the American critic Charles Caffin who wrote, "He did better than attract a few followers and imitators; he influenced the whole world of art. Consciously or unconsciously, his presence is felt in countless studios; his genius permeates modern artistic thought."

In his day, Whistler was as famous for his personality as for his art. He not only fit the characteristics of the nineteenth-century dandy, but he also helped to establish its definition. Standing only five feet, four inches high (1.62 meters) and often dressed outlandishly in outrageous colors and patent-leather pumps, he affected a style of self-conscious eccentricity, projected an aura of confident self-importance, and gave off a cultivated air of aesthetic arrogance. These qualities made him a figure of public scrutiny, controversy, and outrage throughout his career. A century before Andy Warhol broke down the line between art and the commercial media, Whistler understood the value of self-promotion, and his fame and that of his art followed from the stir that he created by shocking the audiences of his time. Known for his sharp wit, he often delighted his friends and followers with clever quips, but just as frequently he alienated them with biting attacks and rebuffs.

Although Whistler clearly enjoyed his notoriety and delighted in seeing his exchanges with other public figures such as the Anglo-Irish author Oscar Wilde repeated in the press, he was utterly serious about art and about his own work. In his "Ten O'Clock Lecture" of 1885, he railed against the popular art of his day and against art with moral purpose. He called for art to be looked "at" not "through," to

Arrangement in Grey: Portrait of the Painter
1872, oil on canvas; 29 1/4 x 20 3/4 in. (74.9 x 53.3 cm). Detroit Institute of Arts, Michigan.
In this self-portrait, which Whistler described as "a fine portrait of myself, life sketch," the artist showed himself in a broad-brimmed hat, his eyes slightly narrowed as if sizing up a potential painting subject.

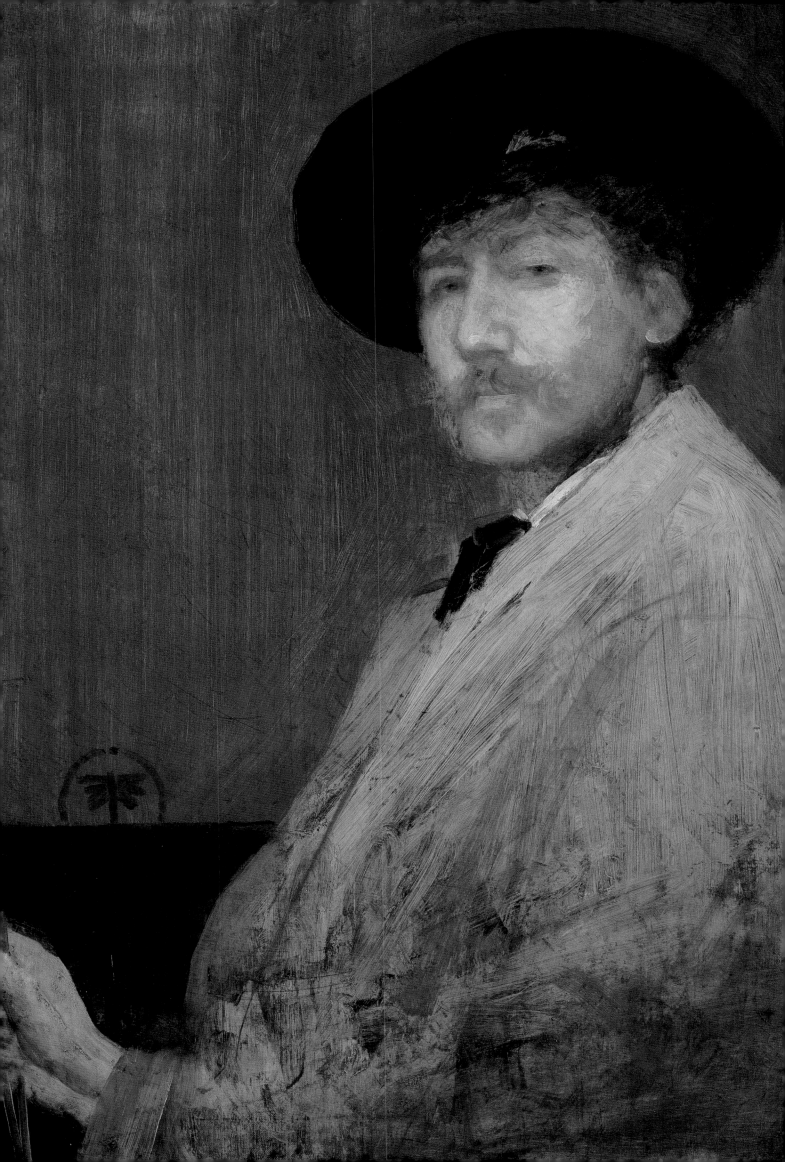

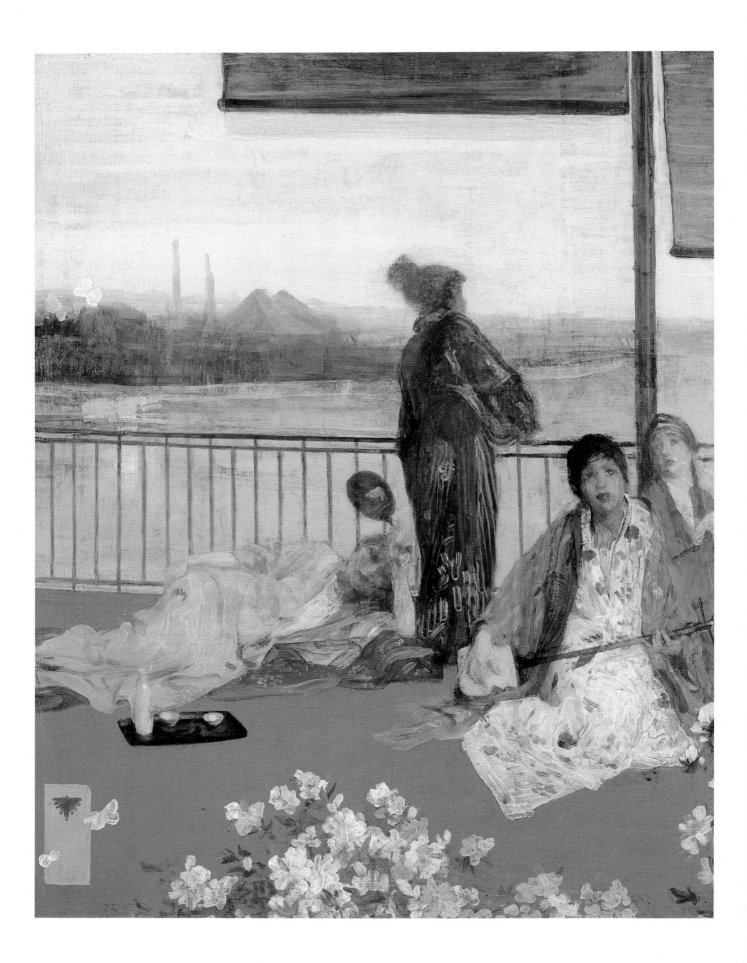

be considered for a beauty that was not linked to virtue. He believed that it was necessary for the artist to go beyond a literal transcription of nature. Nature, he felt, merely contained the elements of color and form from which the artist was to pick and choose, arranging a work like a musician would compose "until he bring forth from chaos glorious harmony."

Whistler did not invent the idea of "art for art's sake," but he was one of the first to explore the idea in the visual arts, using tone and brush handling expressively to produce evocative "arrangements" from portrait and landscape subjects. At the same time, he had a deep love for nature, for the beauty of misty night skies and atmospheric sunsets. Never creating works that were completely abstract, Whistler explained that nature should always be the foundation for a work of art. In the "Ten O'Clock Lecture" he stated, "In all that is dainty and lovable [the artist] finds hints for his own combinations, and *thus* is Nature ever his resource and always at his service, and to him is naught refused."

Whistler was inspired by a range of sources, including the work of Velásquez and Rembrandt, Japanese prints, ancient Greek sculpture, and the English eighteenth-century portrait tradition. However, his works never include obvious references. He simplified his designs, omitting details to create an art of suggestion rather than of reportage. He wanted the expressive nature of tone, line, and form to speak for themselves, and he worked to achieve a look of effortlessness so that the viewer would not be distracted by trying to analyze how an image was created. Whistler expressed his dislike of works that revealed evidence of labor, stating in his 1890 book, *The Gentle Art of Making Enemies*, "A picture is finished when all trace of the means used to bring about the end has disappeared." Creating economical designs in which every stroke or element of color played a significant role, he produced elegant and refined works that are both decorative and poetic.

The story of how Whistler's famous butterfly signature evolved provides a key to his persona and his art. During the mid-1860s, Whistler's fascination with the potter's marks on the blue-and-white china he had begun collecting gave him the idea of signing his name with his initials. Over time, he molded his initials into the shape of a butterfly, an abstract, delicate pattern that became his monogram. This inscription evolved again in 1880. While staying in Venice, Whistler impaled a scorpion on a needle he was using to create etchings. Impressed with the way the scorpion continued to strike out viciously in all directions, he combined the tail of the insect, its stinger, with the graceful butterfly.

The resulting symbol, suggesting both fragility and aggression, sums up an art that was extremely gentle and subdued, yet had considerable shock value during an era when art was still judged by its ability to represent reality. The stinging butterfly also reflects Whistler's personal pugnacity, which masked a sensitive nature that responded to poetic qualities in the places he portrayed and was caring toward the people close to him.

Variations in Flesh Colour and Green: The Balcony

1865, oil on canvas; 24 x 19 in. (61.4 x 48.8 cm). Freer Gallery of Art, Washington, D.C.
In 1889, a writer for *Harper's* called this painting "a Japanese fancy realized on the banks of the gray Thames." The work is, in fact, the only one in which Whistler combined his interests in industrial London and Japonisme.

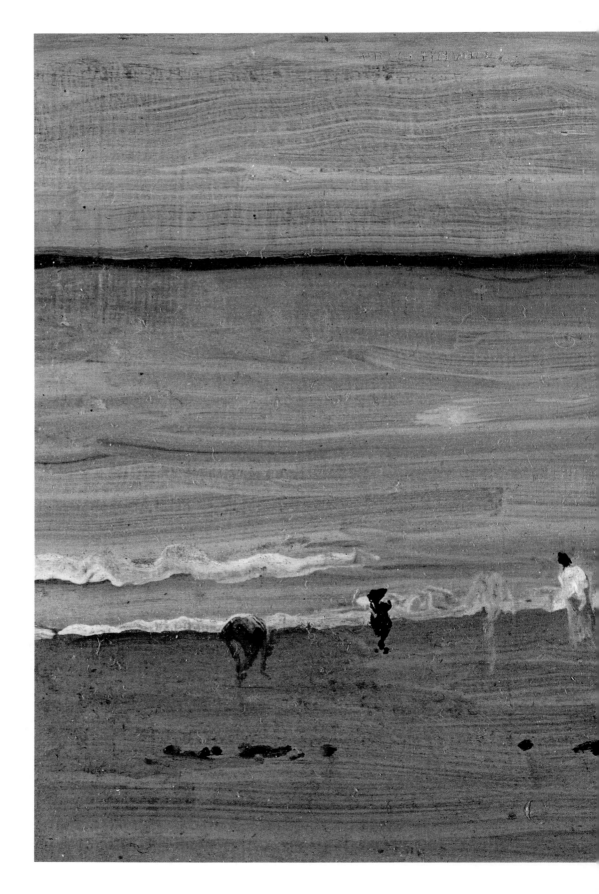

Coast Scene: Bathers

1884–1885, oil on canvas; 5 x 8 1/4 in. (12.7 x 21.5 cm). The Art Institute of Chicago. Probably painted in Dieppe in the fall of 1885, this painting demonstrates the extreme simplicity of Whistler's late style. The beach, water, and sky are treated as bands of color and painted with long, broad strokes of paint. Tiny figures, rendered as dabs of paint, relieve the emphatic horizontals of the composition.

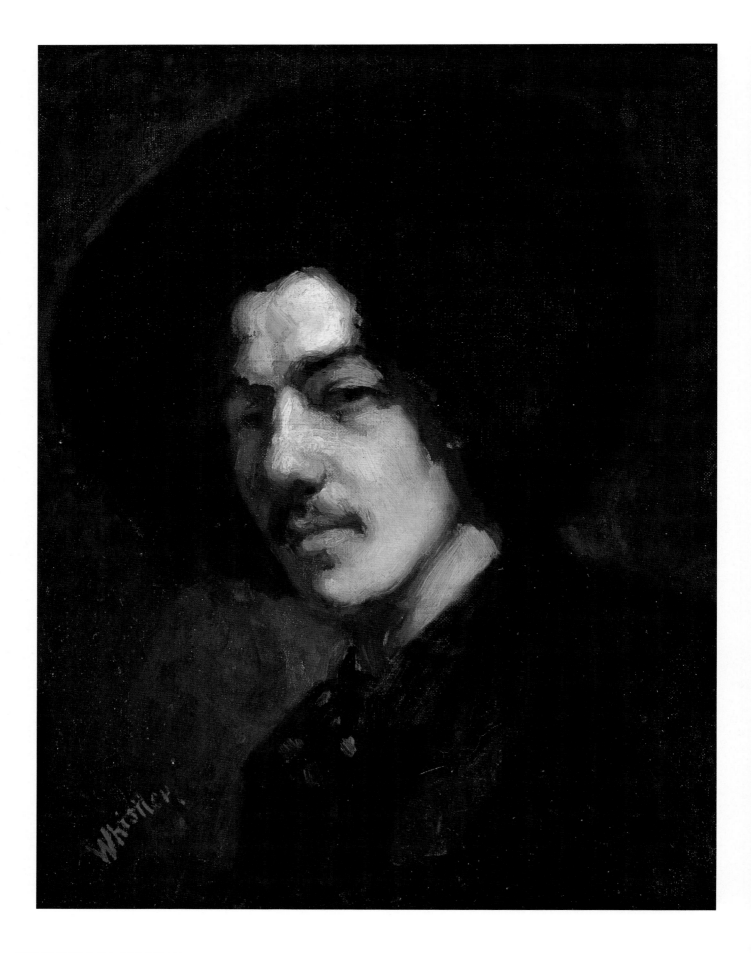

CHAPTER ONE

THE RISE OF A REALIST ARTIST: WHISTLER'S ART AND CAREER TO 1865

*I*f it were left to Whistler to provide information about his place of birth, the truth would never be known. The artist enjoyed giving different accounts of his origins, claiming at times to have been born in Baltimore and at other times to have been born in St. Petersburg, Russia. In an autobiographical fragment, he repeated misinformation to confuse the issue further, stating, "I have read that I was born in Pomfret, Connecticut, in Boston, and even in Lowell!" As if to suggest that the whole question of one's birthplace was absurd and open to debate, he commented, "No, the time has gone by when a man shall be born without being consulted. . . . Meanwhile I have chosen Baltimore.—I was born then in Baltimore." When confronted by an artist who claimed to have shared his hometown of Lowell, Massachusetts, Whistler promptly retorted, "I do not choose to be born at Lowell."

It is nonetheless true that Whistler was born in the mill town of Lowell, Massachusetts, on July 11, 1834. He was the first child of Major George

Portrait of Whistler with Hat

1857–1858, oil on canvas; 18 x 14 7/8 in. (46.3 x 38.1 cm).

Freer Gallery of Art, Washington, D.C.

Whistler's admiration for the Old Masters is demonstrated in this dark and thickly painted self-portrait in which the artist's face emerges from the shadows. In particular, the work evokes Rembrandt's *Portrait of a Man in a Beret*, which Whistler would been able to see at the Louvre while studying in Paris. Whistler signed his name boldly in red, revealing his confidence in his artistic identity even this early in his career.

Washington Whistler, a consulting engineer employed in the construction of railroads, and his second wife, Anna McNeill. Whistler had two older step-siblings born to his father and his father's first wife—George William and Deborah—and one surviving younger brother, William (two other younger brothers died young). Close to his mother, Whistler claimed a connection with her Scottish ancestry as well as with her Southern family, the McNeills of North Carolina. He would accentuate these aspects of his lineage for exotic effect after becoming an expatriate.

An Exotic Youth

Whistler did not need to elaborate on his background; his youth was filled with enough change and adventure of its own accord. Due to Major Whistler's work on the railroad, the family moved twice in a short space of time, to Stonington, Connecticut in 1836, and to Springfield, Massachusetts in 1840. Three years later, the family was more dramatically uprooted when they joined Major Whistler in St. Petersburg, Russia, where he had gone the year before to take up a position as the engineer for a railroad connecting Moscow and St. Petersburg.

The Whistlers were well off in Russia. They hired servants and James and his brother William were taught French by tutors. In Russia, Whistler explored art for the first time. On his own, he began to produce pencil and pen-and-ink drawings and caricatures, and in 1845, he received his first art lessons at the Imperial Academy, where he was taught in the conventional approach of the day to draw from casts.

In 1847, the family traveled to London to attend the wedding of Major Whistler's daughter, Deborah, to Francis Seymour Haden, a physician who was also an amateur etcher; the Hadens would soon play a significant role in Whistler's life. Within the year, the family was back in Russia, but when James came down with rheumatic fever in the winter of 1848, Anna Whistler returned to England with her two sons, leaving her husband behind in Russia to complete his work on the railroad. By the following winter Major Whistler had become ill with cholera, and that spring, he passed away at age forty-nine.

In the summer, Anna Whistler returned to America and settled in Pomfret, in northeastern Connecticut. Endowed with a widow's pension, she raised her sons in a genteel fashion, but frugality ruled the household. The boys were enrolled in Christ Church Hall School, where Anna hoped James would train for the ministry. When this did not turn out to be his calling, arrangements were made for him to attend West Point Military Academy, his father's alma mater.

Whistler's record at West Point was far from exemplary. Known as "Curly" for his dark ringlets, which he did not allow to be cut despite army rules, he constantly racked up demerits for bucking regulations and flaunting authority. During his two years at West Point, his academic record went from satisfactory to mediocre, with his only achievement being in the art classes he took with Robert W. Weir, who instructed the young "plebe" in mapmaking as well as drawing. An artist of note, Weir appreciated Whistler's talent and encouraged him to draw figures and to use watercolors. However, Weir's praise could not keep Whistler from expulsion. When he gave a sarcastic answer during an oral chemistry exam, he was discharged from the school.

Unsuccessful in an attempt to return to West Point, Whistler sought work, and in 1854, he became employed as a map draftsman for the United States Coast and Geodetic Survey. Bored by cartography, Whistler sketched drawings of sea serpents, mermaids, and whales on the margins of a coastal map. When this was discovered, he was transferred to the Survey's etching division. He lasted in this post for only four months, but the instruction he received in etching techniques provided skills that would be critical to his future career.

Life in Paris

Despite his mother's efforts to cajole her son into a practical profession, by the time he left the Survey, Whistler had become determined to pursue art as a career. Having been introduced during his cosmopolitan years in Russia to the caché of foreign study, he declined further training in his native country and he sought exposure to the great art of his day in Paris. With funds provided by his mother, in 1855, he settled into a bohemian existence in the French capital. Inspired by Henri Murger's popular novel, *Scènes de la Vie Bohème* (1848), he took a studio in the Latin Quarter and became immersed in literary and artistic society. He befriended caricaturist and writer George du Maurier and novelist William M. Thackeray.

In 1856, after a short term of study at the Ecole Impériale et Spéciale de Dessin, he enrolled in the studio of Charles Gabriel Gleyre, a Swiss artist working in the classical academic tradition who would later be the teacher of Claude Monet. Gleyre was known for encouraging his students to develop individualistic styles, which was undoubtedly appealing to Whistler. Nonetheless, Whistler's attendance in Gleyre's atelier was sporadic, and soon he was spending more time in parks and cafés than in the classroom. He also took the opportunity to copy art in the Louvre. "What is not worthy of the Louvre is not art," he said at the time.

In the summer of 1858, Whistler took a trip through France with fellow bohemian painter, Ernest Delaunoy. Although intending to travel through northern France, Luxembourg, and the Rhineland, the artists made it only to Vosges, Strasbourg, and Cologne before running out of funds. In spite of the fact that the trip was cut short, Whistler did not return to Paris empty-handed. While traveling, he had created his first etchings of note, producing views of contemporary life such as the interiors of tenement dwellings and streets in poor villages. He had the images printed on Japanese paper in Paris, producing the twelve prints known as *The French Set*.

French Influences

Just before going to London in the fall of 1858, Whistler made a visit to the Louvre where he struck up a conversation with a young artist

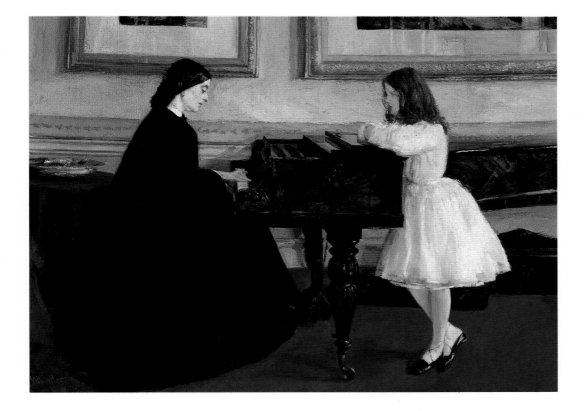

At the Piano

1858–1859, oil on canvas; 26 3/8 x 35 1/16 in. (67 x 90.5 cm). Bequest of Louise Taft Semple, Taft Museum, Cincinnati, Ohio. Whistler depicts his niece, Annie Haden, and her mother, his half sister, Deborah Haden in this view of the music room of the Haden home in London. The composition shows Whistler striving for simplicity. His compositional elements are at a minimum, his palette is limited, and the figures exhibit a restraint by comparison with the sentimentalized images of mothers and children that appeared in contemporary Victorian genre scenes.

engaged in copying an old master work. This was the beginning of his friendship with Henri Fantin-Latour and the start of a new direction in Whistler's thinking and in his art. Fantin-Latour introduced Whistler to a circle of artists inspired by the French realist painter, Gustave Courbet, who was revolutionizing the Parisian art scene with unsentimentalized scenes of ordinary life and undramatic landscapes, which he painted with a heavy use of the palette knife.

Accepted into Fantin-Latour's avant-garde group, Whistler became acquainted with the artists Alphonse Legros, Emile-Auguste Carolus-Duran, Zacharie Astruc, and Edouard Manet. Participating in the progressive art scene in Paris, Whistler absorbed the rich cultural atmosphere surrounding him. He discovered the writings of Symbolist poet Charles Baudelaire, who used musical terms descriptively and expressed disdain for anecdotal art. He read the fiction of Théophile Gautier, who explored the idea of translating the qualities of one medium to another. From his friendship with Fantin-Latour, Whistler learned of the methods of Fantin-Latour's teacher, Lecoq de Boisbraudran, who instructed students to create images from memo-

ry and to study moonlit effects in Paris's Bois de Boulogne.

During 1858, Whistler traveled back and forth between Paris and London, and the impact of the realism adhered to by his Parisian artist friends is reflected in *At the Piano* (1858–1859), which was painted in the Haden's music room in London. In the work, Whistler omitted the excessive detail and overt sentiment typical of Victorian painting, portraying Annie Haden, his niece, listening to her mother's music. The composition is simplified to essential shapes held by a grid of horizontal and vertical elements, including the picture frames on the wall and the post of the piano. The curved shapes of the figures are the work's focus; their respective black and white dresses subtly create a counterpoint that refers to the piano's keys as well as to music. Edouard Manet admired this painting when it was shown at the Royal Academy in 1860.

Whistler departed further from convention in a second view of the Haden's music room. This time, Annie Haden is reading to her mother, who is seen in the reflection in the mirror at the left, while Isabella Boott, a family friend from Boston, is shown in a black riding outfit on the right side

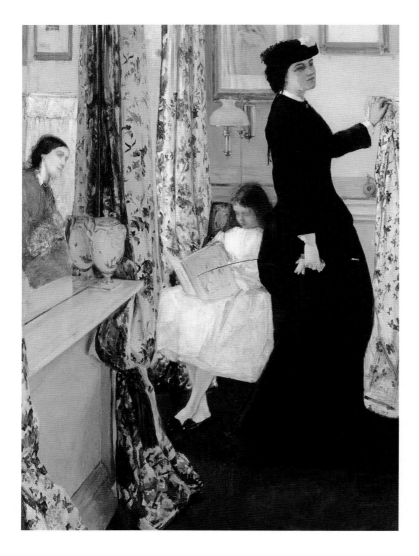

Harmony in Green and Rose: The Music Room

1860–1861, oil on canvas; 37 1/4 x 27 1/2 in.

(95.5 x 70.8 cm). Freer Gallery of Art, Washington, D.C.

In this depiction of the music room at the home of his half-sister, Whistler departed from the type of interior genre scenes painted by artists of his day. With the space flattened and foreshortened to give the viewer multiple angles on the scene, his spatial treatment breaks from traditional perspective. The figures seem to exist in different spaces, and the chintz curtains and framed pictures further divide the room.

of the canvas. The figural relationships are enigmatic; each figure seems to exist in a separate zone, and the space, divided by floral curtains, is ambiguous and claustrophobic.

The painting demonstrates Whistler's rejection of the prevalent idea that a picture had to tell a story, as well as his departure from rules of perspective that had held since the Renaissance. Unified by its compositional balance of color and form, the painting anticipates the abstract qualities that would soon become a keynote of Whistler's art. Although Whistler initially called this painting *The Music Room*, he later added *Harmony in Green and Rose* to its title, emphasizing the importance of its aesthetic qualities over its subject matter.

In 1859, Whistler became part of a loosely formed artists' group with Fantin-Latour and Legros, which became known as the Society of Three. As a result of this association, Whistler met Courbet, who came to see works displayed by the group in the studio of another realist painter, François Bonvin. Meeting Courbet was a high point of Whistler's early career, and he is known to have exclaimed, "He is a great man! A great man!" Yet while French realism had an impact on Whistler's art from the late 1850s through the mid-1860s, his works do not reflect the social and political issues addressed by Courbet. Instead, Whistler was captivated by the idea of rebelling from academic practices, and the notion that art should be based on real experience rather than on art traditions.

Life and Work by the Thames

In 1860, Whistler was back in London and had moved to new lodgings, taking a small, shabby, and narrow apartment at Rotherhithe, a dockside neighborhood in an industrial section of the lower Thames River. He had created eleven copperplates of the Thames in 1859 focusing on the men who worked on barges and along the

wharves. From these, he produced the etchings in his *Thames Set.*

While living on the river a year later, he painted the view before him, focusing on the atmospheric properties of heavy, overcast London skies and the gritty qualities of the urban harbor with its dense network of crowded wharves, boats, and warehouses. This scene, which was distasteful to conventional English painters of the day, had an invigorating effect on Whistler. Indeed, Whistler was so sure that he had struck upon a subject matter of contemporary relevance that he wrote to Fantin-Latour about a painting on his easel entitled *Wapping*: "Hush! don't tell Courbet!," suggesting that the work would arouse the jealousy of the prominent French realist if he were to see it.

In *Wapping,* Whistler portrayed the real London of his time, featuring a group of figures seated casually outdoors at a dockside pub in the work's foreground. Defying traditional compositional rules, he created an asymmetrical and informal design in which the figures are positioned obliquely rather than at the composition's center. The red-haired woman is Joanna (Jo) Hiffernan, who started out as a model for the artist and eventually became his mistress. One of the men is Legros, from the Society of Three. Below the figural group, Whistler accentuated the lively blend of masts, rigging, boats, and buildings that made up the busy harbor.

Another view of the Thames reveals the experimental nature of Whistler's work at this point in his career. In *The Thames in Ice,* Whistler explored the expressive nature of paint and tone. Focusing more on atmosphere than detail, he used thick layers of brown, gray, and white pigment to convey fog, ice, and murky water. The pale lavender-gray silhouette of an industrial complex across the river is faintly visible against the white-gray sky, anticipating Whistler's exploration of subtle color harmonies in the years ahead.

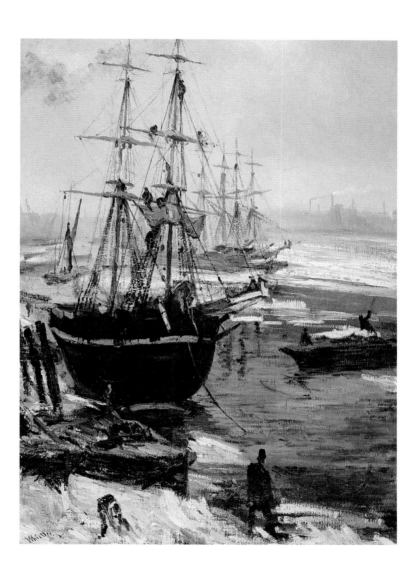

The Thames in Ice

1860, oil on canvas; 29 x 21 1/2 in. (74.6 x 55.3 cm).

Freer Gallery of Art, Washington, D.C.

Whistler records the rare occurrence of ice on London's Thames, capturing the vitality of this scene by applying thick impasto to convey the white patches of ice and the muddy river, which has receded and left a large brig banked in the left foreground. In the distance, a silhouette of London reveals numerous smokestacks.

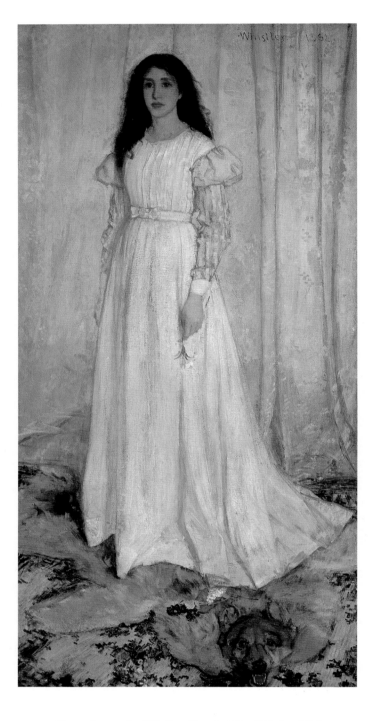

Symphony in White, No. 1: The White Girl

1862, oil on canvas; 84 1/2 x 42 1/2 in. (214.6 x 108 cm). Harris

Whittemore Collection, The National Gallery of Art, Washington, D.C.

With its white on white composition, this painting has

become an icon of the aesthetic movement. In the work,

which portrays Whistler's mistress, Joanna Hiffernan,

the white tonalities suggest innocence, but this image is

undercut by the faded lily in the subject's hand and by

the masculine quality of the bearskin rug beneath her feet.

The White Girl

In 1861, Whistler went to Paris with Jo, who had become his mistress as well as the manager of his business affairs. After traveling with Jo to Brittany, where he recovered from a bout of rheumatism, in the late fall Whistler began a painting of her in his Paris studio in which he decided that the theme would be the color white. He set about rearranging the studio to create the image, moving furniture to one end of the space and placing a white cloth on the wall behind where Jo was to stand. He had Jo dress in a high-waisted white gown and gave her a single white lily to hold. Under her feet, he positioned a wolf-skin rug.

The painting, initially called *The White Girl*, is among his best known. The lily, a symbol of innocence, contrasts with the masculine effect of the rug, leading to interpretations of the painting as a reflection on a young woman's loss of innocence. The critic Castagnary saw the canvas as an allegory of the morning after the wedding night. Whistler's idealization of the figure and his decision to show her in white, a symbol of purity, suggests the influence of the English Pre-Raphaelites, but the use of white throughout most of the canvas made the painting controversial, as did the fact that it did not fit traditional categories; it was not a genre painting, but it was more than a portrait. Indeed, when Whistler submitted the painting to the Royal Academy exhibition of 1862, it was rejected.

Whistler's *White Girl* finally received public attention in 1863, when it was exhibited at the Salon des Refusés exhibition in Paris. This landmark show was sanctioned by the French Emperor Napoleon III, who decreed that the many paintings rejected that year from the Salon would be exhibited after all, but in a separate show. Among the "refused" works, only one received more attention than Whistler's *White Girl*—Edouard Manet's *Déjeuner sur l'herbe*, which shocked Parisian audiences with its display of two clothed men picnicking with a naked woman in a park. But Whistler's painting was widely noticed.

While some of the public found reason to laugh at Whistler's canvas, others—particularly mem-

bers of the avant-garde cultural community—praised both its characterization and its study of a subtle range of white tones. The critic Théodore Duret stated, "She is painted like a vision, which appears not to everybody but to a poet." Courbet called the painting "an apparition with a spiritual content," while another critic, Paul Mantz, referred to it as a *symphonie du blanc*. Whistler may have recalled Mantz's comment when he later added the heading *Symphony in White No. 1* to the work's title.

Things Japanese

After the exhibition, Whistler returned to London and settled into a home on Lindsey Row at the edge of Chelsea. He was soon joined there by his mother, who left America after the Confederacy lost the Civil War (she had been on the side of the South because of issues of land ownership rather than of slavery). For Whistler, the location of his new home provided a new opportunity: the possibility of becoming acquainted with members of the Pre-Raphaelite circle who gathered in Chelsea at "Tudor House," the residence of painter and poet Dante Gabriel Rossetti at 16 Cheyne Walk.

At Tudor House, Whistler was thrust into London's literary bohemian society. In addition to meeting the artists in the Pre-Raphaelite circle, including John Everett Millais and Ford Madox Brown, he fraternized with poets, writers, and theorists including Algernon Swinburne, George Meredith, and John Ruskin.

At one of Rossetti's gatherings, Whistler met Christine Spartali, the daughter of the Consul-General for Greece in London, who became the subject for *La Princesse du Pays de la Porcelaine* (1863–1864). In this work, Whistler depicted his sitter in a lavish Japanese kimono standing within an interior decorated with a wide variety of Oriental objects. The languid bend of the figure's pose echoes the fold of the screen behind her, establishing her integral role in the decorative scheme. The pattern on her fan is linked to design elements in the screen, uniting foreground and background. The painting demonstrates Whistler's deep immersion in the *Japonism* craze which swept the art worlds of Paris and London beginning in the 1860s.

La Princesse du Pays de la Porcelaine

1863–1864, oil on canvas; 78 x 45 1/4 in.
(199.9 x 116 cm). Freer Gallery of Art, Washington, D.C.
The sitter in this painting was the daughter of the Greek consulate in London, who commissioned the work from Whistler. Whistler showed his subject unconventionally: Dressed in Japanese attire, she stands languidly, with her form seemingly supported by the upright accordions of the Japanese screen.

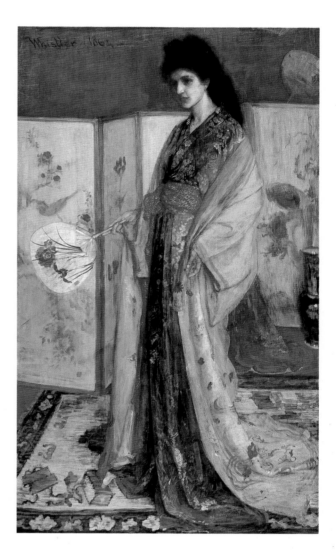

Indeed, Japanese paraphernalia dominates in several of Whistler's other important works of the mid-1860s. He never traveled to Asia but, frequenting Parisian antique shops and outdoor markets, he furnished his home at Lindsey Row with a plethora of Asian objects including Chinese porcelain, Japanese prints, screens, fans, and even some furniture. Asian works of art appealed to him because they provided him

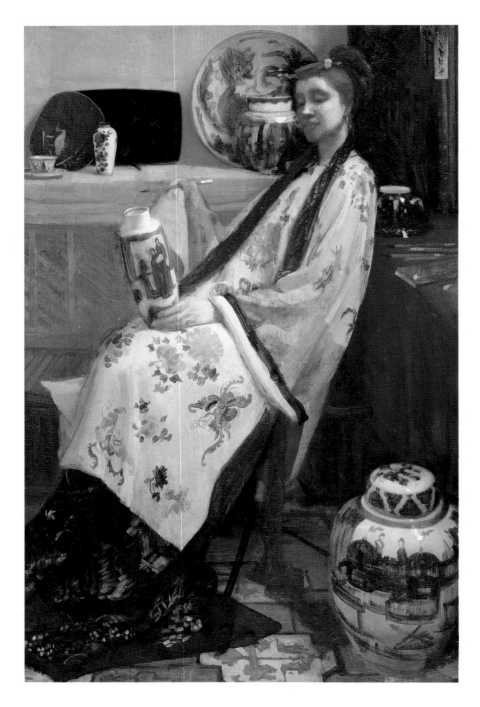

**Purple and Rose: The Lange Leizen
of the Six Marks (Lady of the Land Lijsen)**

1864, oil on canvas; 36 3/4 x 24 1/8 in.

(91.5 x 61.5 cm). The Philadelphia Museum of Art.

"Lange Lijzen" is Dutch for "long elizas," the blue and white
Chinese porcelain decorated with "long ladies." The "Six Marks"
refer to the potter's marks that appear on the china. Such marks
gave Whistler the idea of signing his name with his butterfly
monogram. In this painting, the figure is elongated as on the
china, but Asian influence is not present otherwise in the design.

with a model for liberating him-
self from the conventions of
Western perspective and
chiaroscuro. But Whistler did
not mimic Japanese designs slav-
ishly. His biographer Joseph
Pennell explained that Whistler's
"idea was not to go back to the
Japanese as being greater than
himself, but to learn what he
could from them, to state it in his
own way and produce another
work of art."

Whistler was also taken purely
with the exotic appeal of things
Japanese. He filled his home with
Japanese fans, screens, and
porcelain, creating an environ-
ment that showed off his taste. He
conveyed his delight in the
refined and decorative richness
of the Orient in *Caprice in Purple
and Gold: The Golden Screen*
(1864) and *Purple and Rose: The
Lange Leizen of the Six Marks*
(1864). In *Caprice*, the figure's
shape echoes the folds in the
screen behind her and the hori-
zontal format of the work.
Dressed in a kimono and studying
Japanese prints, the figure
reveals an absorption in aesthet-
ics that reflects Whistler's own
outlook.

In *Purple and Rose*, Whistler con-
veyed his fascination with the pat-
terns of blue-and-white Chinese
porcelain, called by the Delft
name of "Lange Leizen" (Long
Elizas) in the Netherlands. Here the figure is not
only surrounded by blue-and-white china objects,
but is also engaged in painting on one herself. She
is an element in the decorative arrangement, and
is also seen actively creating it. In her dual role,
Whistler made an obvious reference to himself.
The potter's marks on blue-and-white porcelain
gave Whistler the idea of designing a unique mark
for himself, which led to the invention of his but-
terfly signature.

Whistler, Courbet, and Jo

After Whistler's mother arrived in London and took up residence with her son in Lindsey Row, Jo continued to be Whistler's mistress and caretaker even though she was forced to take lodgings elsewhere. Whistler featured her in several works of the mid-1860s, including *Caprice in Purple and Gold* and *Symphony in White, No. 2: The Little White Girl*. The latter work shows a wistful Jo lost in contemplating an Oriental vase. Here Whistler shows her as an object of beauty, like the vase, allowing us to admire both her profile and her face reflected in the mirror behind her.

With his mother ruling his home, Whistler had little time to spend alone with Jo; one of the only ways he could do so was to leave London. In the summer of 1865, he took her to the Normandy resorts of Trouville and Deauville. There the couple was joined by Gustave Courbet, who was painting seascapes in his uniquely vigorous style. Courbet was so enamored of Whistler that he wrote to his parents that Whistler was his pupil. This was not true, but the two artists respected each others' work. In *Harmony in Blue and Silver: Trouville*, Whistler expressed his admiration for Courbet in a pure seascape in which a lone figure stands his ground with the wide expanse of water and sky before him.

Courbet, however, was impressed not only with Whistler—he was also taken with Jo, whose flaming red hair he praised. But when Jo modeled for the French painter, Whistler was not pleased. He was angry that Jo would willingly sit for Courbet, and the sense that she had betrayed him eventually led to the dissolution of their relationship. In the wake of the Normandy trip, Whistler also turned vehemently against Courbet and the realist art he had pioneered. In 1876, Whistler wrote to Fantin-Latour, "Courbet and his influence was disgusting. . . . I am not complaining of the influence his paintings had on my own. He did not have any and it can't be found in my canvases. . . . All that he represented was bad for me. . . . Ah! If only I had been a pupil of Ingres. . . . What a master he would have proved, and how he would have healthily led us."

Indeed, whatever truth there is to Whistler's statement, by the mid-1860s, he had turned from a commitment to Courbet's strong color and realist approach to a new focus on tone and design. A new, poetic sensibility, combined with a concern for idealized view in which nothing is extraneous or out of place, was what he associated with the work of the early nineteenth-century French Neoclassicist Jean-Auguste-Dominique Ingres, even though Whistler did not paint sensual nudes, the subject matter for which Ingres is famous.

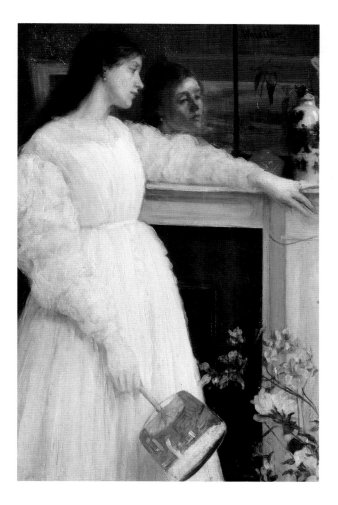

Symphony in White, No. 2: The Little White Girl

1864, oil on canvas; 29 1/2 x 20 in. (76 x 51 cm). The Tate Gallery, London.

In this painting, Whistler depicts his mistress Joanna Hiffernan gazing at a Chinese vase while catching a glimpse of her own beauty in the mirror behind her. The subject's self-awareness gives this work a psychological content. At the same time, the painting is among Whistler's most beautifully composed, with the vertical of the figure balanced by the horizontal of the mantelpiece on which her arm gently rests.

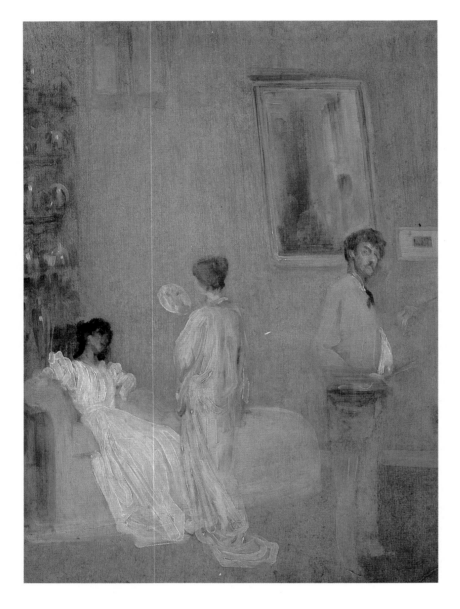

Whistler in his Studio

1865, oil on canvas; 24 1/2 x 18 in. (62.9 x 46.4 cm). The Art Institute of Chicago.
Whistler began this painting as a much larger canvas, which he intended
to show at the Paris Salon. However, instead of completing it as planned,
he cut it down into two works, both of which included his portrait. Here,
holding his painter's palette, the artist scrutinizes a subject beyond the
canvas's frame, which is vaguely suggested in a mirror. The painting is
the opposite of Velásquez's famous *Las Meninas*, in which a portrait of the
Spanish Royal Family includes a mirror in which the artist himself appears.

The Last of Old Westminster

1862, oil on canvas; 24 x 30 1/2 in. (61 x 77.5 cm).

Abraham Shuman Fund, Museum of Fine Arts, Boston.

Despite its title, this painting depicts the construction of London's new Westminster bridge. Whistler executed it directly from a window looking at the scene, and, while working over the course of a few weeks, he changed the position of elements frequently.

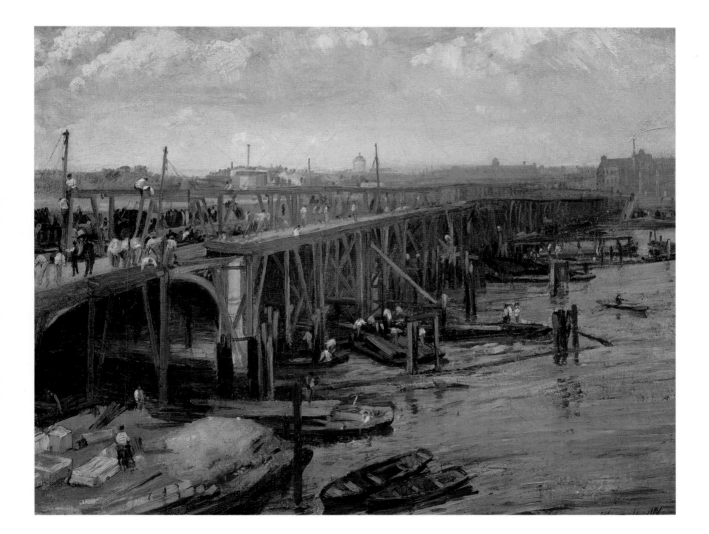

Brown and Silver: Old Battersea Bridge

1859, oil on canvas; 25 1/8 x 29 5/16 in. (63.5 x 76.2 cm). Gift of Mr. Cornelius N. Bliss, Addison Gallery of American Art, Phillips Academy, Andover, Massachusetts.
Rendered in a subdued palette of gray and brown, this painting captures the industrial character of London's Thames River at mid-century. Whistler's emphasis on the bridge's plunge shows that he was already exploring radical compositional strategies at this early point in his career. The figure between the barge and the water is a self-portrait.

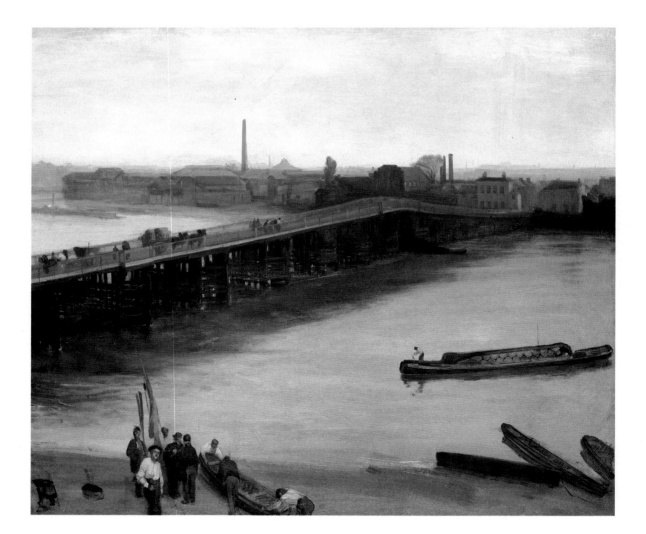

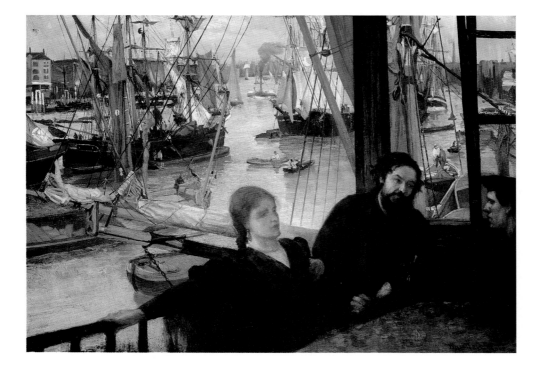

Wapping On Thames

1860–1861, oil on canvas; 28 x 40 in. (71.1 x 101.6 cm). John Hay
Whitney Collection, The National Gallery of Art, Washington, D.C.
Whistler shows the deck of an inn that overlooked
the Thames in this view of the Wapping section of
London. The presence of the figures socializing with
London's gritty harbor behind them was too unconven-
tional for the Royal Academy, which rejected the work.

Following page:
Caprice in Purple and Gold: The Golden Screen

1864, oil on canvas; 19 1/2 x 26 3/4 in.
(50.2 x 68.7 cm). Freer Gallery of Art, Washington, D.C.
Whistler shows his mistress Joanna Hiffernan
studying Japanese woodblock prints. With
the figure posed as artistically as the objects
surrounding her, the work is about the
contemplation of beauty, which was
Whistler's interest throughout all of his art.

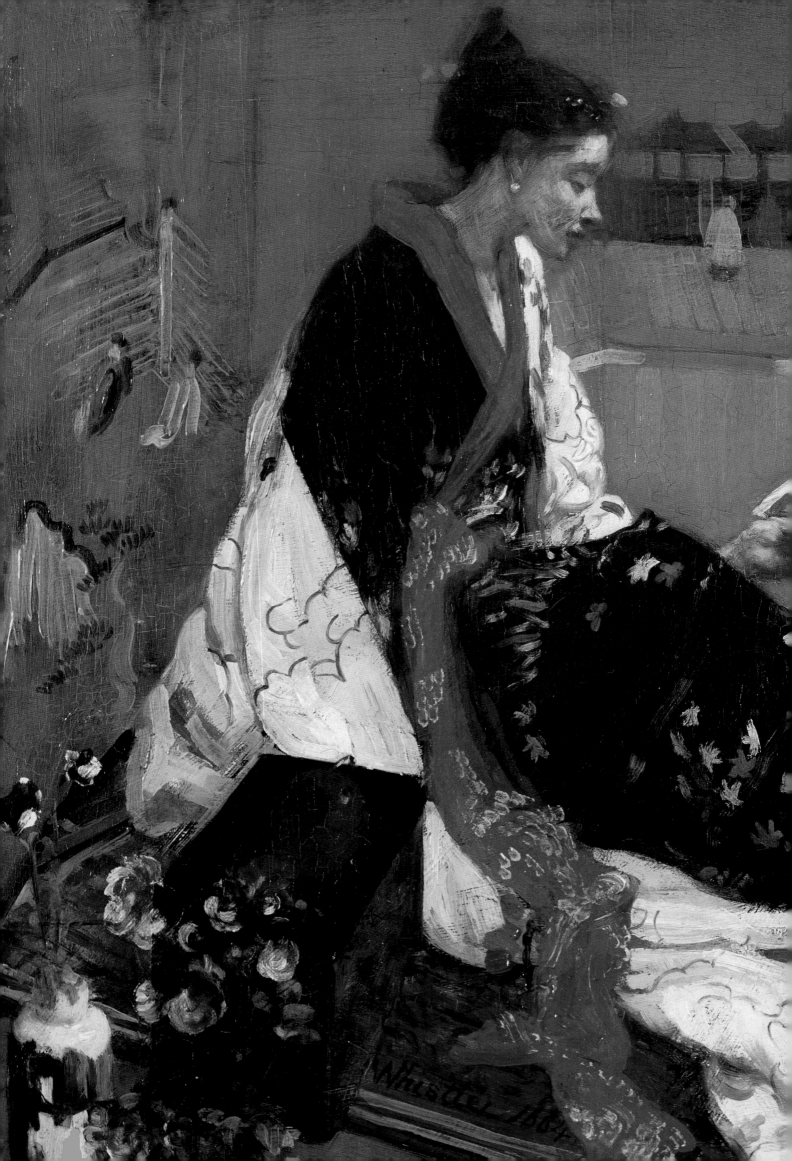

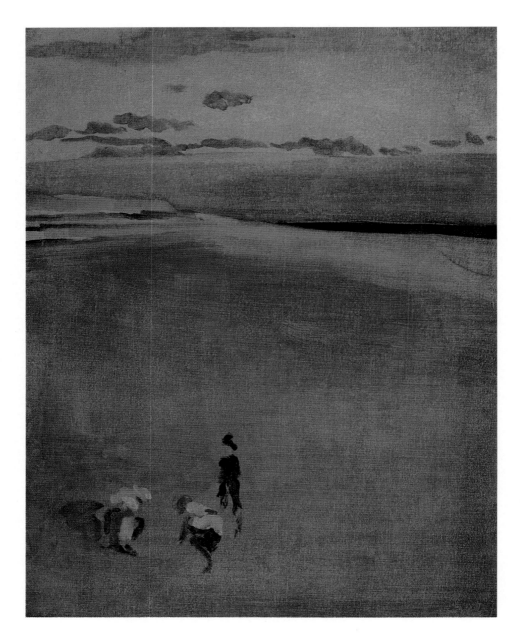

The Beach at Selsey Bill

c. 1865, oil on canvas. New Britain Museum of American Art, Connecticut.

The high horizon in this work tilts the picture plane forward rather than drawing us back into space. Whistler thus emphasizes the balance of color rather than creating a landscape meant to be read according to traditional perspective. The figures add a decorative touch rather than providing narrative elements, further revealing the fact that this is a picture made up of color and shape rather than a view of a specific scene.

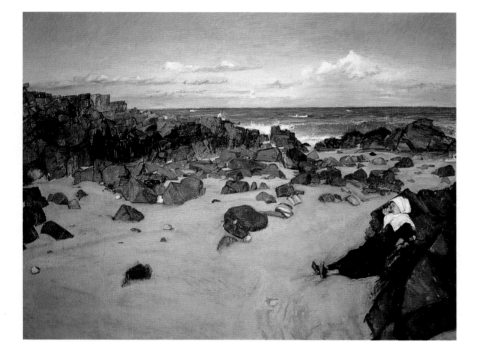

The Coast of Brittany

1861, oil on canvas; 34 x 45 in.
(87.3 x 115.8 cm). In memory of
William Arnold Healy, given by his
daughter, Susie Healy Camp, Wadsworth
Atheneum, Hartford, Connecticut.
Rendered in Brittany, where Whistler
had gone for his health in 1861, this
painting was titled *Alone with the
Sea* when it was shown at the Royal
Academy in 1862. The work demon-
strates the influence of the French
realist Gustave Courbet on Whistler,
although the large block of open
space in the foreground and the
high horizon are elements not
found in Courbet's art. Indeed,
they would soon be hallmarks of
Whistler's unique abstract style.

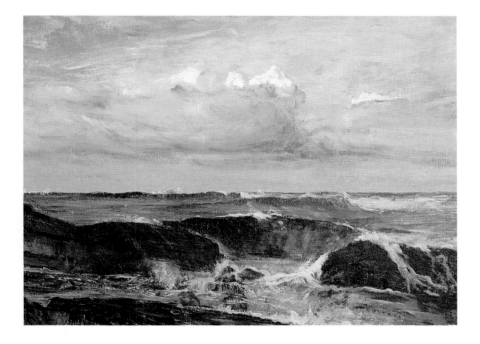

The Blue Wave: Biarritz

1862, oil on canvas; 24 1/2 x 34 1/2 in.
(62.2 x 87.6 cm). Hill-Stead Museum,
Farmington, Connecticut.
Whistler created this painting while
staying in Guéthary, Basses-Pyrénées
in October–November of 1862. The
image shows the influence of Courbet,
especially Whistler's thick paint and
the image of breaking waves. Yet
Whistler's reduction of the rocks
to flat shapes and his painting of
the sky with long, fluid strokes
demonstrates an interest in treating
nature in abstract terms that departs
from Courbet's realist approach.

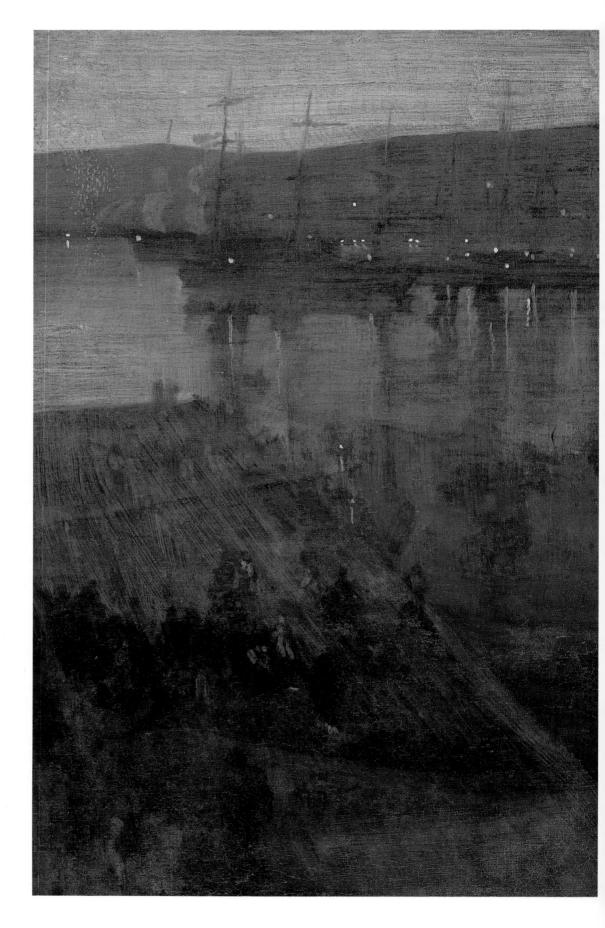

Nocturne in Blue and Gold: Valparaiso Bay

1866, oil on canvas;
29 1/2 x 19 1/2 in.
(75.6 x 50.1 cm).
Freer Gallery of Art,
Washington, D.C.

Executed from a window at a club in Valparaiso, Chile, this painting was Whistler's first nocturne. From an overhead perspective, the view across the darkened harbor captures the magical experience of night, when forms lose their recognizable shapes. The wharf in the foreground, where scattered figures may be made out, is flattened and the hulls of ships have become soft fuzzy lines while gold dots represent harbor lights.

CHAPTER TWO

ART FOR ART'S SAKE: 1866-1878

Perhaps the most unusual episode in Whistler's career was the trip he took in 1866 to Chile during that country's war with Spain. Whistler's explanation for making the journey was that he felt guilty about remaining passively in London during the American Civil War. The artist's brother William had been active in the Civil War as a surgeon for the Confederate army, while James, who had attended West Point, had not been patriotic enough to return home and join up.

The war between the Spanish and the Chileans was not of much consequence, however. It consisted of an aggressive naval attack by the Spanish on the Chilean harbor of Valparaiso over the nonpayment of tariffs incurred when the South American country had still been a colony. The encounter that took place involved little aggression: The Spanish courteously burned only a few homes and the Chileans did not bother to return fire. Thus, Whistler's expedition did not engage his military skills. Nonetheless, the trip had a dramatic impact on the artist and had lasting implications for his art.

Valparaiso

Joseph Pennell recorded Whistler's impressions of the scene that he encountered:

> There was the beautiful bay with its curving shores, the town of Valparaiso on one side, on the other the long line of hills. And there, just at the entrance of the bay, was the Spanish fleet, and, in between, the English fleet, and the French fleet, and the American fleet, and the Russian fleet, and all the other fleets. And when the morning came, with great circles and sweeps, they sailed out into the open sea, until the Spanish fleet alone remained.

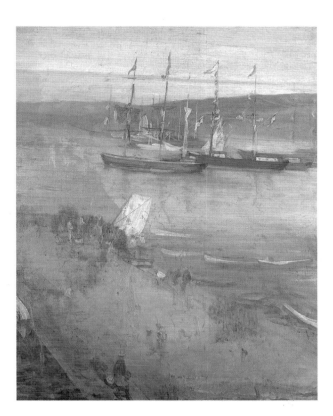

The Morning after the Revolution, Valparaiso

1866, oil on canvas; 29 1/2 x 24 3/4 in.

(76 x 63.5 cm). Hunterian Art Gallery, Glasgow.

Whistler went to Chile in 1866 to take part in the defense of the nation against the Spanish. As it turned out, the military action was brief and the artist did not see any fighting. This painting of a quiet harbor, where ships with their masts down and flags flying, suggests the calm aftermath of the uneventful "revolution."

The three known paintings that Whistler created of Valparaiso are not battle scenes. Painted in soft pale blue and light green tonalities, with boats rendered as hazy shapes, these works are Whistler's first nocturnes. In *Crepuscule in Flesh Color and Green: Valparaiso*, the scene is viewed as if through a soft-focus filter; the hulls and masts of ships are softly edged and the pale pinks and blues of dusk are echoed in the smooth turquoise-toned sea.

In *Nocturne in Blue and Gold: Valparaiso Bay*, docks, ships, and coastal hills emerge as dark

**Nocturne in
Black and Gold:
Entrance to
Southampton Water**

1872 or 1874, oil on canvas;

20 x 30 in. (50.8 x 76.2 cm).

The Art Institute of Chicago.

A high horizon empha-
sizes the broad empty
expanse of water that
covers most of this
work. The scene is
softly illuminated
by the last light from
the setting sun, while
tiny dots of yellow
paint represent the
gaslit glow of the
distant town.

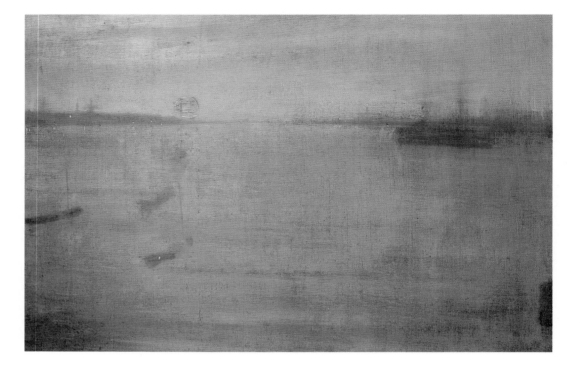

shapes defined only by the glimmer of artificial light, which also creates sparkling dots at intervals on the far shore. The asymmetrical arrangement and the broad treatment of shapes reveal the influence of Japanese prints as well as Whistler's growing concern for decorative issues of form and color.

The Nocturnes

After returning to London, Whistler continued to concentrate on night scenes, creating his famous series of nocturnes depicting the Thames. Hiring his friends, brothers Walter and Henry Greaves, to take him out in boats, he spent a great deal of time on the river sketching at dusk with black and white chalk on brown paper, on which he noted relationships of bridges, buildings, lights, and shorelines.

In his studio, he used his drawings as the basis for paintings, but he also often relied on his memory. During walks along the Thames, he would gaze at the scene before him and then turn his back, trying to recollect what he had seen. He tested himself until he recalled not only a site's details, but also tonal relationships such as the lightness of the sky relative to the water and

houses. With the nocturnes, Whistler began to use musical titles. He called his works "harmonies" and "variations," suggesting that a work could be experienced purely on a sensuous level, as a mood rather than a representation of a particular scene or a story.

To create his paintings, Whistler would proceed by thinning his paints with linseed oil or turpentine. He then let his thin pigments saturate his canvases, producing a subtle range of tonal effects. Once he had prepared the ground, he used his brushes delicately to add flickering touches of color, indicative of the fugitive shapes of shadows, harbor lights, architectural structures, bridges, boats, and reflections on the water. His final step was to set his canvases out to dry in the sun.

In his nocturnes, Whistler let a single color predominate. As he later told Fantin-Latour, his idea was that "color ought to appear in the picture continually here and there, in the same way that a thread appears in an embroidery, and so should all the others, more or less according to their importance; in this way the whole will form a harmony. Look how well the Japanese understood this. They never strive for contrast; on the con-

trary, they seek repetition."

That Whistler's nocturnes lacked narratives troubled his audiences, and Whistler felt obliged to defend himself. He wrote to the London *World* of a snow scene that included a single figure and a tavern: "I care nothing for the past, present or future of the black figure, placed there because black was wanted at that spot. All I know is that my combination of grey and gold is the basis of the picture. Now this is precisely what my friends cannot grasp."

Yet Whistler did not fully depart from the painting of modern life. One of the subjects he portrayed most often in his nocturnes was Cremorne Gardens, a popular pleasure park along the Thames where crowds gathered to dance on an open-air stage that was illuminated at night by gaslight. Varied amusements were available at Cremorne including a bowling alley, a theater for marionettes, and a bandstand. For some of the works in which he depicted the park, Whistler observed Cremorne's lights from the water, showing nightly fireworks that sent flickering colors into the darkened sky. Closed by 1877 due to complaints about its noisy, raucous crowds, Cremorne Gardens exists today only in Whistler's paintings.

Nocturne: Blue and Silver— Cremorne Lights

1872, oil on canvas; 19 1/2 x 29 1/4 in.
(50.2 x 74.9 cm). The Tate Gallery, London.
Whistler captures the vaporous morning mists on the Thames River. Layering pale blue tones over an orange ground, he shows the pale morning light casting a veil over the water; the yellow glow of the Cremorne section of London is visible in the distance.

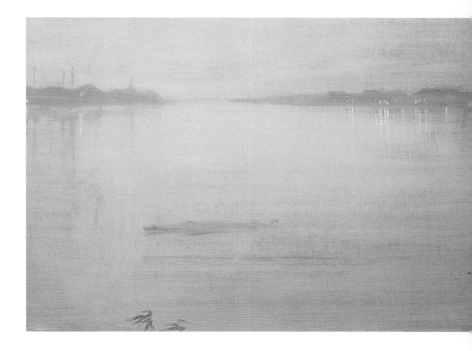

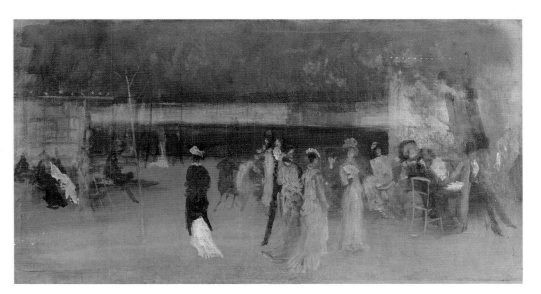

Cremorne Gardens, No. 2

1872–1877, oil on canvas;
27 x 53 1/8 in. (68.5 x 135.5 cm).
John Steward Kennedy Fund,
1912, The Metropolitan
Museum of Art, New York.
In London's Cremorne Gardens, an amusement park along the Thames that existed during the 1870s, figures are strolling and conversing in the evening light. The scene captures a new phenomenon of Whistler's age made possible by gaslight—the rise of outdoor urban night life.

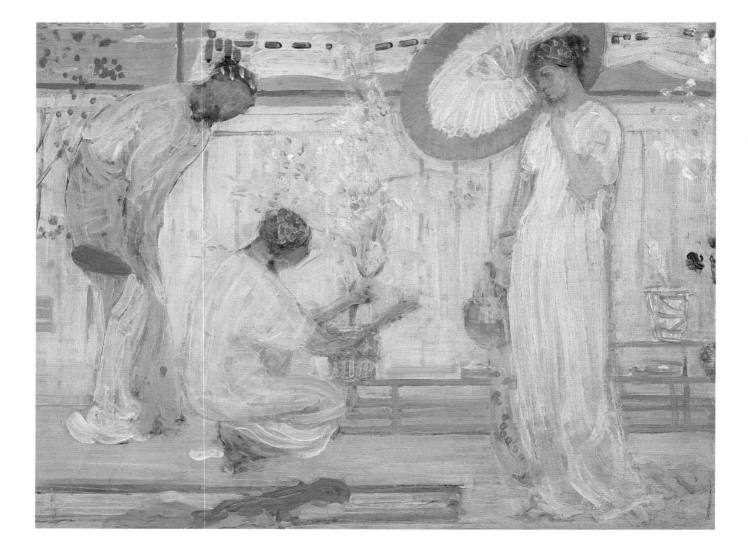

The White Symphony: Three Girls

c. 1868, oil on panel (from the Six Projects*); 18 x 24 in.*
(46.4 x 61.6 cm). Freer Gallery of Art, Washington, D.C.

In the *Six Projects*, Whistler created a series of images
that he planned to use as the basis for an architectural
decorative scheme. However, the scheme was never
completed, and the images were not installed. Instead,
they stand alone as experiments in which Whistler brought
together a great variety of influences including Japanese
prints, classical Greek friezes, and Tanagra figures.

The Six Projects

In addition to initiating a new landscape art, in
the late 1860s, Whistler created a new type of fig-
ural image in a series of oil sketches known as *The
Six Projects*. These works, featuring languorous
women in flowing, diaphanous gowns, were
intended as architectural decorations, but they
were never completed or installed. They demon-
strate Whistler's talent at synthesis. In the works,
Whistler brought together a number of influences:
The pseudo-classical style of the figures emulates
the art of the English painter Albert Moore; the
simplicity of Whistler's lines, his use of linear
accents, and his asymmetrical designs reveal his
homage to Japanese woodblock prints; the frieze-
like arrangements reflect Whistler's study of the

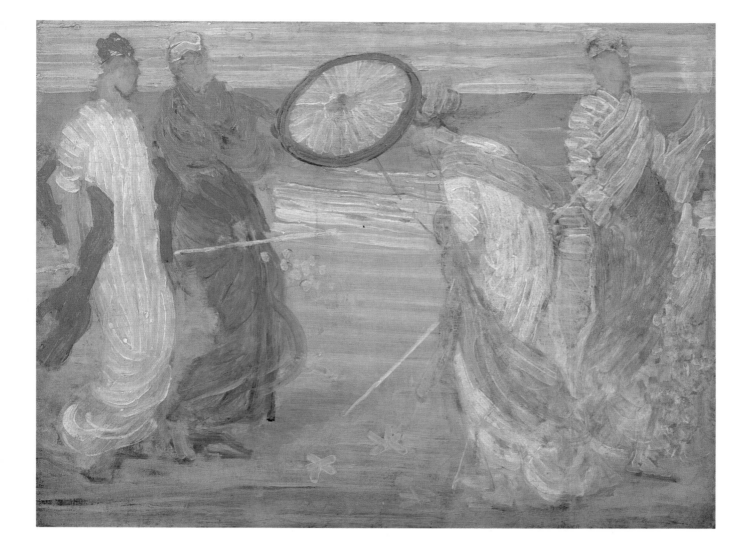

Elgin Marbles; and his delicate colors and gracefully swaying figures suggest his awareness of the graceful forms of Tanagra figures from Boetia, a group of which belonged to the British Museum.

Whistler also established a new painting technique in the *Projects*, applying his brushes in bold streaks on his panel surfaces so that the paint itself is an element of his designs. With its filmy paint texture, gentle, flowing strokes, and graceful figures, *The White Symphony: Three Girls* reveals the "exquisite fluttered grace of action" that the poet Algernon Swinburne saw in the *Six Projects*. In *Symphony in Blue and Pink*, the swaying figures are linked by their sinuous curves, which echo the rounded form of the parasol at the center of the image.

Symphony in Blue and Pink

c. 1868, oil on panel (from the Six Projects*).*

Freer Gallery of Art, Washington, D.C.

Forms are more animated in this image from the *Six Projects* than they are in *The White Symphony: Three Girls*. The lithe movement of the four willowy women is conveyed by the figures' poses and by Whistler's flowing strokes of watery paint.

Arrangement in Gray and Black

In the early 1870s, Whistler also returned to portraiture, producing works that were equally as radical as his nocturnes and figural studies. He focused his attention in 1871 on a subject he knew well: his mother, who sat for him in a straight-backed chair, wearing a black dress and white lace cap. An inspiration for Whistler in creating the image was the work of the seventeenth-century Dutch painter Franz Hals, in particular Hals' *Old Ladies* (the regentesses of the Haarlem almshouses). Whistler appropriated Hals' clean lines and essentially monochromatic palette, but he did not follow Hals' method of creating a work in a single sitting, despite his admiration for the approach. Instead, he subjected his mother to innumerable sittings, which she accepted stoically, although she later recalled thinking to herself, "I silently lifted my heart that it [the painting] might be cast down in the Lake at the Lord's will."

Her pinched and frozen expression conveys her tenseness as well as her patience. Tightly holding a lace handkerchief and sitting upright, her dark shoes positioned on a small footstool, Whistler's mother appears rigid and controlled. What makes this painting so compelling is that the subject's attitude is so perfectly reflected in the work's design. The austere design matches the figure's reserve, while her stillness is accentuated by the severe geometry of picture frames and curtains that echo the horizontal and vertical elements of her pose.

For Whistler, the painting was more than a portrait. He entitled it *Arrangement in Gray and Black*, and stated, "To me it is interesting as a picture of my mother; but what can or ought the public to care about the identity of the portrait?" Whistler felt that the public should be able to admire the work for its composition and its expression of the subject's character. When he sent the painting to London's Royal Academy, it was rejected, but when Sir William Boxall, a prominent academician, saw the work, he threatened to resign if it

was not accepted. The Academy reversed its decision, but then hung it in the worst possible place.

Public reaction to the work was negative, and the critics considered the painting an experiment rather than "art," but artists and other members of literate London society perceived its greatness. Among those to value the work was the shipowner Frederick Leyland, who hung it prominently at his home near Liverpool, where he positioned it in his main banquet room beside a portrait by Velásquez. Eventually the French government bought the work for the Luxembourg Museum. Today it hangs in the Louvre.

Four Portraits

Another appreciator of Whistler's painting of his mother was the writer/historian Thomas Carlyle, who a short time later himself became a subject for Whistler. Carlyle's experience as a portrait subject for Whistler was as annoying as it had been for the artist's mother. A friend described the sessions: "Carlyle tells me he is sitting to Whistler. If C. makes signs of changing his position, W. screams out in agonized tones: 'For God's sake, don't move!' C. afterwards said that all W's anxiety seemed to be to get the coat painted to ideal perfection; the face went for little."

The portrait that resulted disproves these comments. Carlyle's thoughtful and melancholic expression conveys both resignation and intellect. The faded grays in the space and framed images on the wall give the work a feeling of somber quietude in keeping with the subject's demeanor. Whistler recognized these qualities in the portrait, writing that it "is a favourite of mine. I like the gentle sadness about him!—perhaps he was even sensitive—and even misunderstood—who knows!"

While Whistler was creating his portrait of Carlyle, he was also working on an image of Cicely Alexander, the nine-year-old daughter of a London banker. Whistler advised the girl's mother about his young sitter's attire, even going to far as to choose the fabric for her dress. Like others who

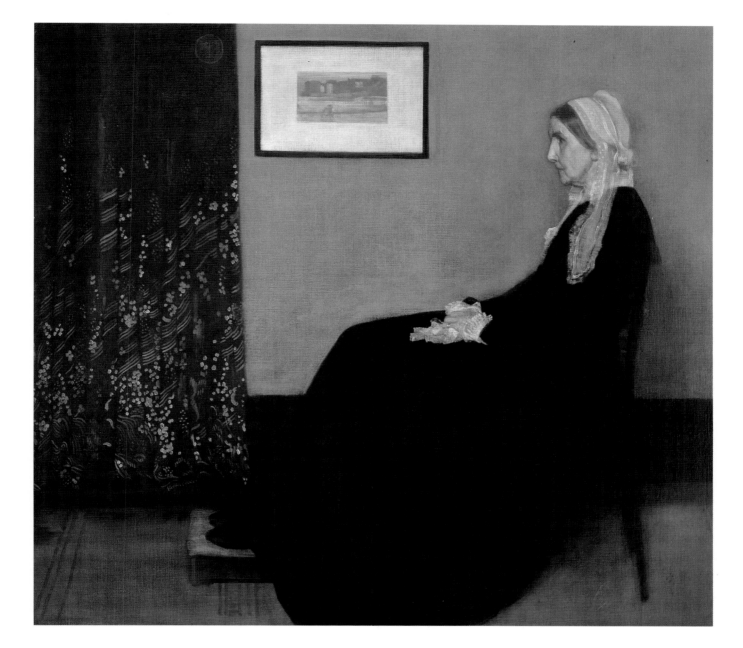

sat for Whistler, Alexander found being a subject for Whistler a trial of her patience. Of her approximately seventy sittings, she recounted to the Pennells, "I'm afraid that I considered myself a victim all through the sittings, or rather standings, as he never let me change my position, and I believe I sometimes used to stand for hours at a time."

Alexander's pose—with her body turned in a three-quarter view and her face toward the viewer—reflects the influence of Velásquez. Indeed, this portrait, with its pearly beige, gray, and

Arrangement in Grey and Black: Portrait of the Painter's Mother

1871, oil on canvas; 56 1/4 x 63 1/4 in.
(144.3 x 162.4 cm). Musée d'Orsay, Paris.

Among the best known works by an American artist, this painting of a very serious religious woman sitting stoically with her hands grasping a lace handkerchief has been the subject of numerous parodies. Even during its day, it was lampooned by critics, including one who said that Whistler should have acknowledged that the portrait showed his mother "after her death."

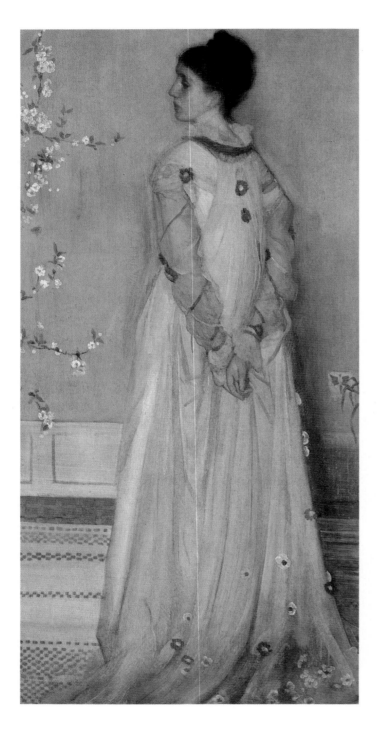

Symphony in Flesh Colour and Pink:
Portrait of Mrs. Frances Leyland

1871–1874, oil on canvas; 76 3/4 x 39 1/2 in.

(196.9 x 102.2 cm). The Frick Collection, New York.

This elegant portrait depicts the wife of the London banker
who commissioned Whistler to work on the Peacock Room.
The subject's poise and aristocratic bearing are expressed in
the elongation of the figure, her clasped hands held behind
her back, and the interplay of white, gold, and pink tones.

green tones, vertical composition, and elongated
figure is among Whistler's most Velásquez-
inspired works. The young girl has the regal bear-
ing of one of the Spanish master's portraits of
royal children.

During the 1870s, Whistler also created por-
traits of Frederick and Frances Leyland. He strug-
gled with both, working on them over the course
of many years. In his depiction of Frederick, he
created an arrangement in black, but the image
caused him problems as the figure's face and
hands became too ghostlike against the dark
background. Eventually, he was able to get the
right balance, with the figure's dark silhouette
gently emerging in the shadowed atmosphere
surrounding him.

For his portrait of Frances, he used a range of
gentle pink tones complemented by gold touches
in the wall's wainscoting and the flowers that
adorn the figure's dress. With her back to us and
her face in profile, the portrait captures the sub-
ject's aristocratic bearing. The graceful, long lines
of Mrs. Leyland's dress, the delicate branches of
almond blossoms that float in the space, and
Whistler's flowing strokes of translucent, pale
color complement the sitter's elegance.

The Peacock Room

Whistler's portraits of the Leylands as well as
his Carlyle were included in the one-man show
that the artist arranged of his work at Henry
Graves's Flemish Gallery in London in 1874.
Whistler designed the gallery in the spirit of one
of his arrangements: The walls were painted gray,
and the space was decorated with palms, flowers,
and blue-and-white pots. The exhibition was not a
critical or popular success, but it launched
Whistler's career as a decorator, which reached
its culmination in the famous Peacock Room.

This project began in 1876 when Leyland turned
to Whistler for help in fixing the dining room of
his home at 49 Princes Gate in London. Leyland's
design decisions in the room had been horren-
dous. He had initially hired Thomas Jeckell to
provide the decor for the room, which was to
have walls covered with red floral-embossed
Cordova leather and was to display Leyland's

large collection of blue-and-white china. At the head of the room, Whistler's *La Princesse du Pays de la Porcelaine* was to be the room's focal point. The combination turned out to be atrocious, and Leyland turned to Whistler to "harmonize" the space. Leyland left Whistler in charge while he went away for the summer, asking him simply to make minor adjustments, including cutting off the red border on the rug and toning down the red flowers in the walls.

Whistler made these changes, but he did not stop with them. He began adding more and more gilt to the walls and ceiling, which he charged to Leyland. He then started to paint peacocks, some in large wall panels and others in smaller panels featuring peacock-feather motifs. Whistler explained to the Pennells, "Well, you know, I just painted on. I went on—without design or sketch—putting in every touch with such freedom—that when I came round to the corner where I started, why, I had to paint part of it over again, as the difference would have been too marked. And the harmony in blue and gold developing, you know, I forgot everything in my joy in it."

On completion, the room was utterly transformed to the point that when Thomas Jeckell saw it, he became mentally ill and never recovered his sanity. Leyland's reaction to the room was also one of shock. He thought it had been ruined and that his blue-and-white china collection would be lost in the richness of the gold-toned space. Even in the face of Leyland's rage, Whistler maintained his equilibrium. He is known to have said, "Ah, I have made you famous. My work will live when you are forgotten. Still, perchance, in the dim ages to come you will be remembered as the proprietor of the Peacock Room." This, indeed, has proved true. Leyland never came to see the beauty of the room, and it was eventually dismantled. Luckily, it has been reinstalled, largely intact, in the Freer Gallery in Washington—though without the blue-and-white china it was supposed to highlight.

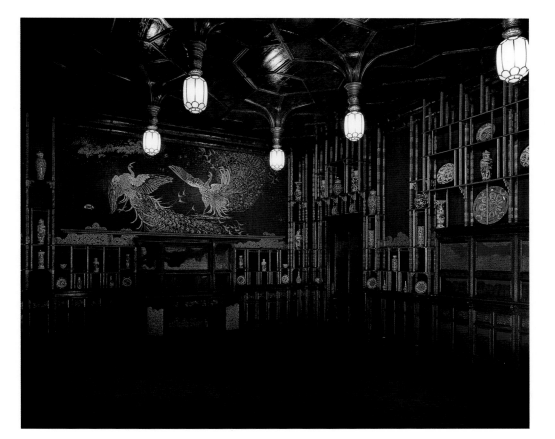

Harmony in Blue and Gold: The Peacock Room

1876–1877. Freer Gallery of Art, Washington, D.C.

Whistler's famous design for the dining room of Liverpool ship-builder Frederick Leyland was supposed to be an adaptation of the existing design by architect Thomas Jeckyll. Instead of bringing the space into harmony, Whistler transformed it into an interior filled with the shimmer of gold and turquoise paint, and Leyland refused to pay him for the work.

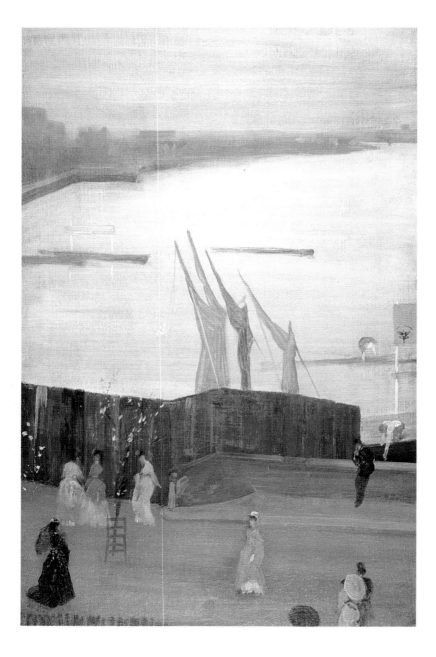

Variations in Pink and Grey: Chelsea

1871, oil on canvas; 24 1/2 x 15 3/4 in. (62.7 x 40.5 cm). Freer Gallery of Art, Washington, D.C.
This painting was one of the first in which Whistler began to use Japanese prints
not as a source of imagery, but as an aid to his compositions. The wall along the
wharf has the appearance of a Japanese screen, and the arrangement is designed in
distinct registers in which flat shapes of masts and barges create rhythmic accents.

Symphony in Grey and Green: The Ocean

1866–72, oil on canvas; 31 1/2 x 39 3/4 in. (80.7 x 101.9 cm). The Frick Collection, New York.
Painted during Whistler's 1866 trip to Chile, this is one of the artist's three
views of Valparaiso harbor that are known today. A view of the sea at dusk,
the work is rendered with long strokes of thin pigment. The high horizon
emphasizes the open space and the textured surface.

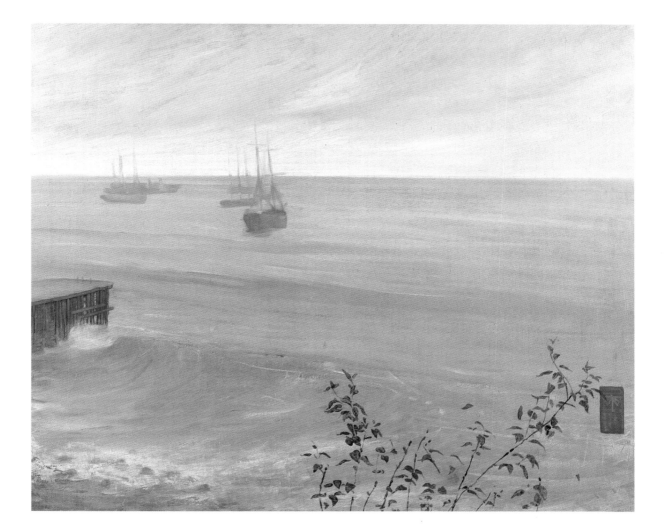

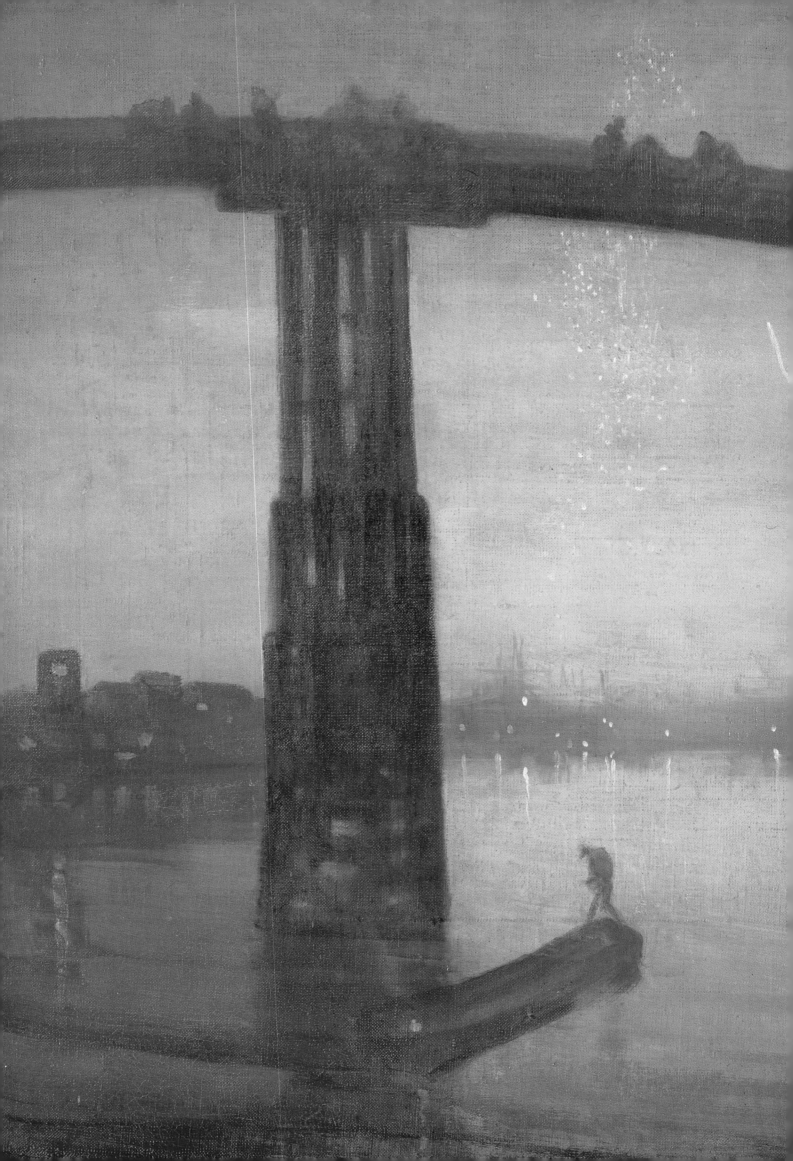

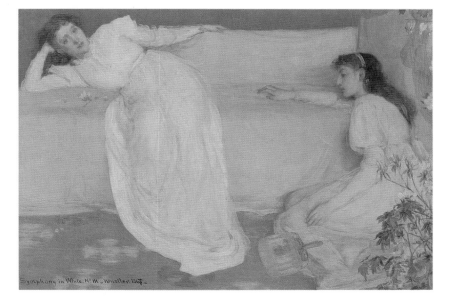

Symphony in White, No. 3.

1865–1867, oil on canvas; 20 1/4 x 30 in. (52 x 76.5 cm).

Barber Institute of Fine Arts, University of Birmingham.

This painting demonstrates the interest in classical subject
matter that Whistler would continue in the *Six Projects*. Dressed
in white, the figures lounge in such a way as to conform with
architectural lines. The figure on the left completes the line of
the sofa with her bent elbow. The French Impressionist Edgar
Degas admired this painting and made a sketch of it in a notebook.

Nocturne: Blue and Gold—Old Battersea Bridge

1872–1873, oil on canvas; 26 x 19 1/2 in. (66.6 x 50.2 cm). The Tate Gallery, London.

This poetic image—in which London's Battersea Bridge is illuminated against
the night sky by fireworks and the distant lights of the city—was mocked by
critics during Whistler's day. When the artist was asked whether his image
was a correct representation of the bridge, Whistler replied: "I did not intend it
to be a correct portrait of the bridge, but only a painting of a moonlight scene."

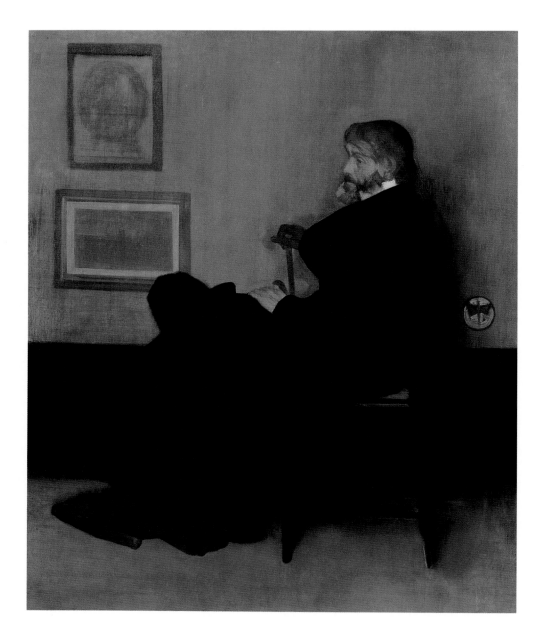

Arrangement in Gray and Black, No. 2: Portrait of Thomas Carlyle

1872–1873, oil on canvas; 66 3/4 x 56 in. (171. x 143.5 cm). City Art Gallery, Glasgow.

This portrait of the Scottish historian and philosopher Thomas Carlyle is similar in format to Whistler's painting of his mother. The monochromatic palette gives the work a quiet, somber feeling that matches the melancholic, wistful gaze on Carlyle's face.

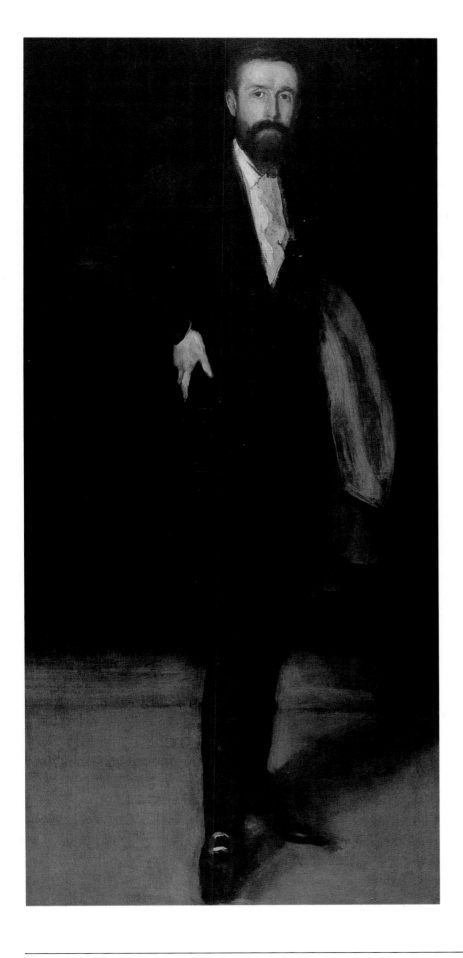

**Arrangement in Black:
Portrait of F. R. Leyland**

1870–1873, oil on canvas;
75 x 36 in. (192.8 x 91.9 cm).
Freer Gallery of Art, Washington, D.C.
The subject of this painting,
Liverpool shipbuilder
Frederick Leyland, was a
collector of Renaissance art
as well as paintings by the
Pre-Raphaelites. Leyland was
also one of Whistler's major
patrons in the early 1870s.

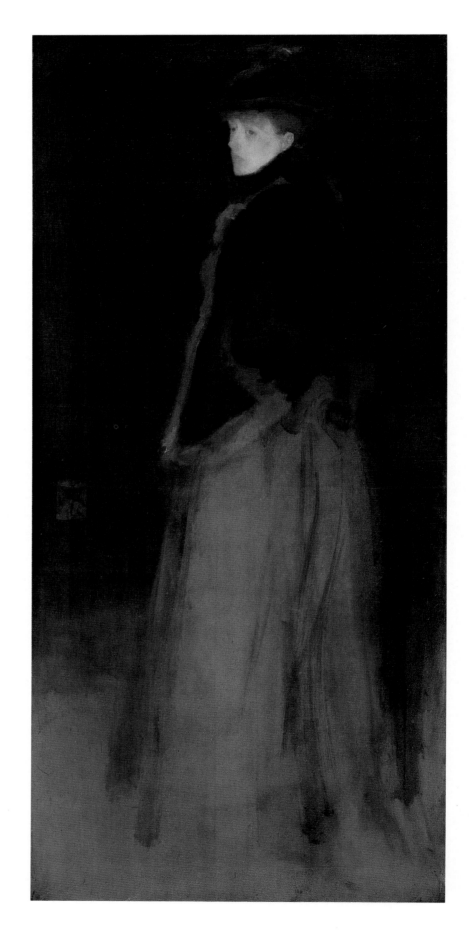

**Arrangement in
Black and Brown:
The Fur Jacket**

*1876, oil on canvas;
75 1/2 x 36 in.
(194 x 92.7 cm).
Worcester Art Museum,
Massachusetts.*

In this portrait of Maud
Franklin, Whistler's mis-
tress in the 1870s and
1880s, the subject's pale
complexion and wistful
gaze are given emphasis
by the rich brown and
black tones that frame
her in her clothing
and the background.

**Harmony in
Grey and Green:
Miss Cicely Alexander**

1872–1873, oil on canvas;
74 x 38 1/4. (190 x 98 cm).
The Tate Gallery, London.
The second daughter of
a London banker, Cicely
Alexander is shown in a
carefully arranged pose with
her feet turned out and her
face tilted toward the viewer.
During modeling sessions,
Whistler frequently reduced
Alexander to tears, not
allowing her to change her
position and keeping her
longer than he had promised.

Chelsea Wharf: Grey and Silver

c. 1875, oil on canvas; 24 1/4 x 18 1/16 in. (61.5 x 45.8 cm). Widener Collection, The National Gallery of Art, Washington, D.C.

Whistler used firm brushstrokes to render masts and rigging in this image of the Chelsea waterfront at night. The scene demonstrates the unique short-hand method in which the artist reduced forms to their essentials.

Nocturne: Trafalgar
Square, Chelsea, Snow

c. 1875–1877, oil on canvas; 18 1/2 x 24 1/4 in.
(47.2 x 62.5 cm). Freer Gallery of Art, Washington, D.C.
This is one of the few views of snow
by Whistler. Through the mist and
snow-filled air can be seen a modest
square and the blurred outlines of
low-rise buildings around its perimeter.

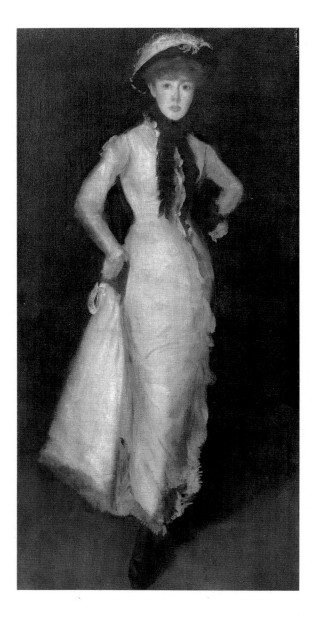

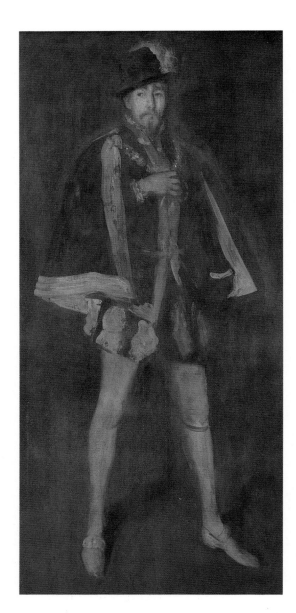

Arrangement in White and Black

c. 1876, oil on canvas; 74 1/2 x 35 1/2 in.
(191.4 x 90.9 cm). Freer Gallery of Art, Washington, D.C.

Whistler shows his mistress Maud Franklin
dressed fashionably in this portrait, accentuating
the way the long dark ties of her hat stand out
against her white form-fitting gown. Franklin's
direct gaze suggests her take-charge personality.

Arrangement in Black, No. 3:
Sir Henry Irving as Philip II of Spain
in Tennyson's *Queen Mary*

1876–1885, oil on canvas; 84 3/4 x 42 3/4 in. (215.3 x 108.6 cm).
Rogers Fund, 1910, The Metropolitan Museum of Art, New York.

After seeing Henry Irving perform the part of
Phillip II in Alfred, Lord Tennyson's play *Queen Mary*
at London's Lyceum Theater in 1876, Whistler
asked the actor to pose for him. Whistler's ability
to record Irving's stance was noted by Oscar Wilde,
who commented that the figure "though apparently
one-armed is so ridiculously like the original that
one cannot help laughing when one sees it."

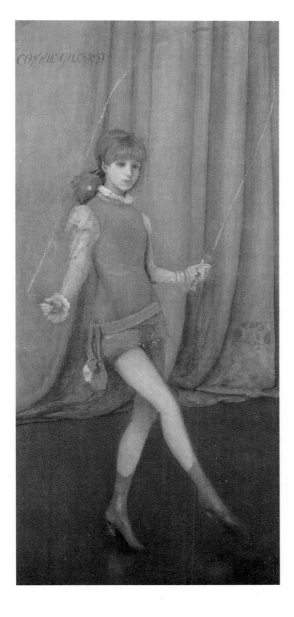

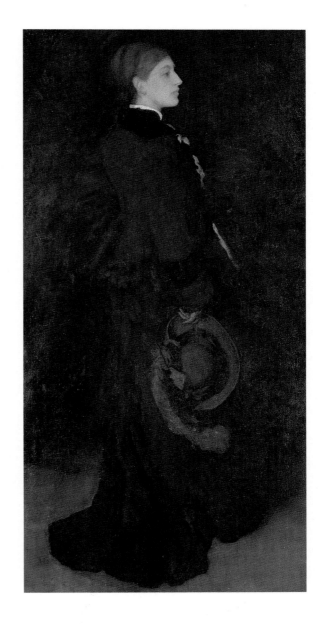

Harmony in Yellow and Gold:
The Gold Girl—Connie Gilchrist

1876–1877, oil on canvas; 85 x 42 3/4 in.

(217.8 x 109.5 cm). Gift of George A. Hearn, 1911,

The Metropolitan Museum of Art, New York.

This painting depicts a twelve-year old girl who
was a skipping rope dancer for London's Gaiety
Theater. The work is significant as it is one of
Whistler's only images of a figure in movement.

Arrangement in Brown and Black:
Portrait of Miss Rosa Corder

1876–1878, oil on canvas; 75 x 36 in.

(192.4 x 92.4 cm). The Frick Collection, New York.

This painting of Rosa Corder, a painter and etcher
as well as a forger of eighteenth-century portraits,
was commissioned by Whistler's friend, Charles
Howell, who was having an affair with her. Whistler
got the idea for the work when he saw Corder
passing through a black door in a brown dress.

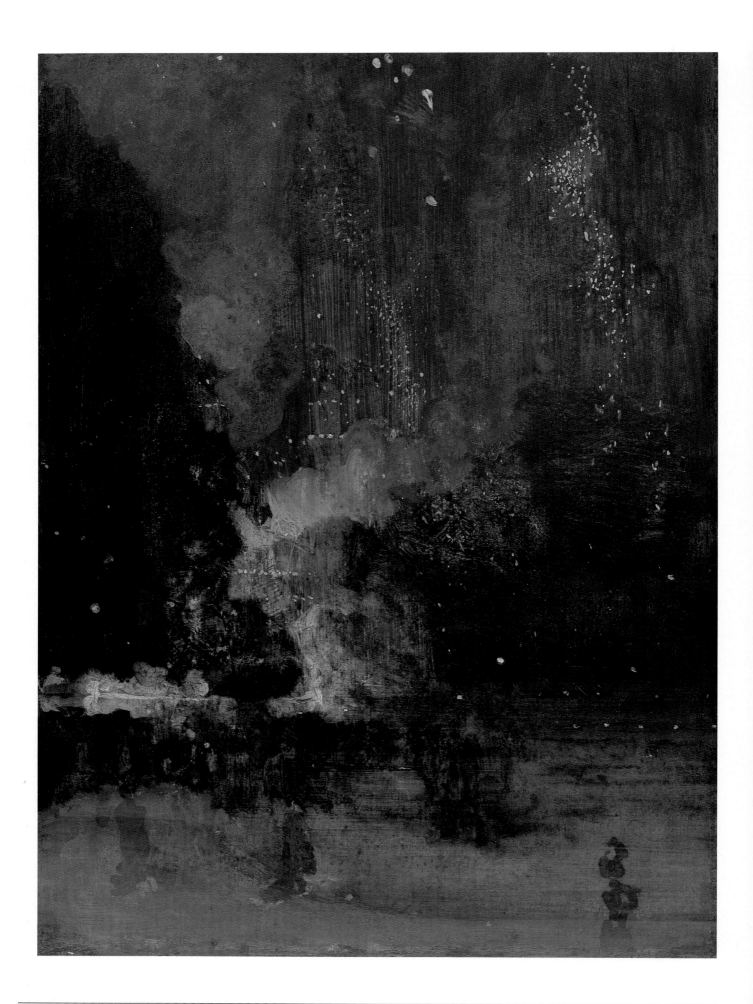

CHALLENGES AND SUCCESSES: 1879-1903

In 1877, Whistler participated in the first exhibition at London's Grosvenor Gallery, which had been established as an alternative to the Royal Academy. The eight works he sent to the show were too pale and subdued to hold up well in the richly decorated space, and the press compared them negatively with the bright and pristine paintings by such Pre-Raphaelite and academic artists as Lawrence Alma-Tadema, Edward Burne-Jones, John Everett Millais, and Frederick Leighton. Among the visitors to the show, none was more venomous in criticizing Whistler's contributions than the theorist John Ruskin. On seeing Whistler's view of the fireworks on the Thames at Cremorne Gardens, *Nocturne in Black and Gold: The Falling Rocket*, he pronounced in *Fors Clavigera*, "I have seen and heard much of cockney impudence before now, but never expected to hear a coxcomb ask two hundred guineas for flinging a pot of paint in the public's face." This comment incensed Whistler, who decided forthwith to sue for libel.

Despite Whistler's expediency in his counterattack, it took a year for the case to come to trial. While waiting, Whistler decorated the house he was building for himself in Chelsea, which he called the White House. Again using the peacock in a design that featured patterns of gold and yellow, he created a spare and austere space that included green woodwork, flat wall colors, and simple furniture. Admired for its clean, uncluttered look, as well as for its economy, the house became influential in English interior design in the years to come. Yet despite this success as an interior designer, Whistler's career as a painter suffered while he waited for his date in court. With Ruskin's comments in mind, the public did not take his work seriously, and he was forced to borrow money from friends to get by.

Whistler vs. Ruskin

The proceedings finally began in 1879. Whistler's case was flawed from the beginning. In his opening statement, Whistler's lawyer praised Ruskin as having a "high position as an art critic." Then the prosecution's case was compromised because many of the artists on whom Whistler had counted to take his side refused to do so out of fear that they would be tarred by his reputation. The three who did testify turned out to offer little assistance to the plaintiff. Painter William Rossetti gave lackluster praise to Whistler's work. Another painter, Albert Moore, called Whistler's painting exquisite and marvelous, but because he was himself considered eccentric, his testimony was not taken as seriously as it could have been. The third artist, William Gorman Wells, a minor Irish playwright, was virtually unknown, and therefore did not add much force to Whistler's argument.

When the defense began its cross-examination, Ruskin's lawyer brought out Whistler's nocturne on its side, producing laughter from the jury. When asked whether his painting was a view of Cremorne, Whistler replied, "If it were called a view of Cremorne, it would certainly bring about nothing but disappointment on the part of the beholders. It is an artistic arrangement." When Whistler answered a question from the defense about how long it had taken him to paint the

Nocturne in Black and Gold: The Falling Rocket

1875, oil on canvas; 23 1/2 x 18 in. (60.3 x 46.6 cm).

Detroit Institute of Arts, Michigan.

This is the famous painting that led to Whistler's libel suit against the theorist and critic John Ruskin. Today it is hard to imagine that an image of fireworks in a dark sky could have appeared so radical, but the audiences of the artist's day could not appreciate Whistler's exploration of color and light without explicit reference to its subject.

work, he responded that it had taken two days. The defense lawyer replied, "The labor of two days, then, is that for which you ask two hundred guineas?" Whistler's answer was: "No, I ask it for the knowledge of a lifetime." This time the laughter that ensued from the audience was in Whistler's favor.

With Ruskin too ill to be in court, his lawyer, Sir John Holker, made the point that Whistler's nocturnes, symphonies, arrangements, and har-

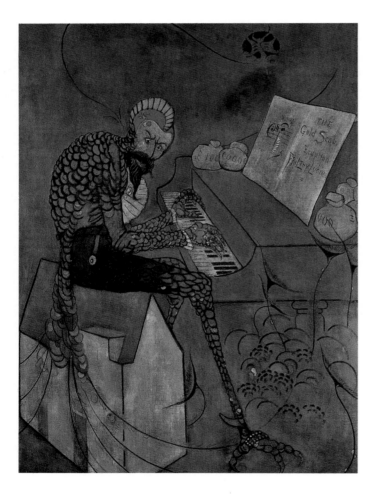

The Gold Scab

1879, oil on canvas; 73 1/2 x 55 in. (186.6 x 139.7 cm). California Palace of the Legion of Honor, The Fine Arts Museum of San Francisco. Whistler intended this image as a satirical view of Frederick Leyland, the Liverpool shipping baron who had formerly been his patron. Leyland, who played the piano in real life, is shown as a demonic peacock with a stinger on his tail, playing the piano. The painting was Whistler's way of getting back at his former patron, who was the artist's major creditor when he became bankrupt.

monies "were not worthy of the name of great works of art." He claimed that such works were "a mania that should not be encouraged; and if that was the view of Mr. Ruskin, he had a right as an art critic, to fearlessly express it to the public." Holker stated that if Whistler disliked ridicule, he should not have subjected himself to it, and that Ruskin's pen should not be controlled through the medium of a jury.

Unlike Whistler's witnesses, the artists who spoke on Ruskin's behalf were impressive to the jury. The Pre-Raphaelite Sir Edward Burne-Jones criticized Whistler's work primarily for being incomplete, while the academician and realist painter William Powell Frith noted that Whistler's paintings had "pretty color which pleases the eye, but there is nothing more." The third witness for the defense was Tom Taylor, playwright, editor of *Punch*, and art critic for the *London Times*. His testimony consisted of reading excerpts from newspaper columns which contained his denouncements of Whistler's work as "in the region of chaff."

A Hollow Victory

The judge's instructions to the jury also did not help Whistler. The honorable Baron Huddleston stated that:

> The question for the jury is, did Mr. Whistler's ideas of art justify the language used by Mr. Ruskin? And the further question is whether the insult offered—if insult there has been—is of such a gross character as to call for substantial damages. Whether it is a case for merely contemptuous damages to the extent of a farthing, or something of that sort, indicating that it is one which ought never to have been brought into court, and in which no pecuniary damage has been sustained; or whether the case is one which calls for damages in some small sum as indicating the opinion of the jury that the offender has gone beyond the strict letter of the law.

Taking the judge's instructions to heart, the jury reached a verdict that rebuffed both plaintiff and defendant. They decided in favor of Whistler, but awarded him only a farthing.

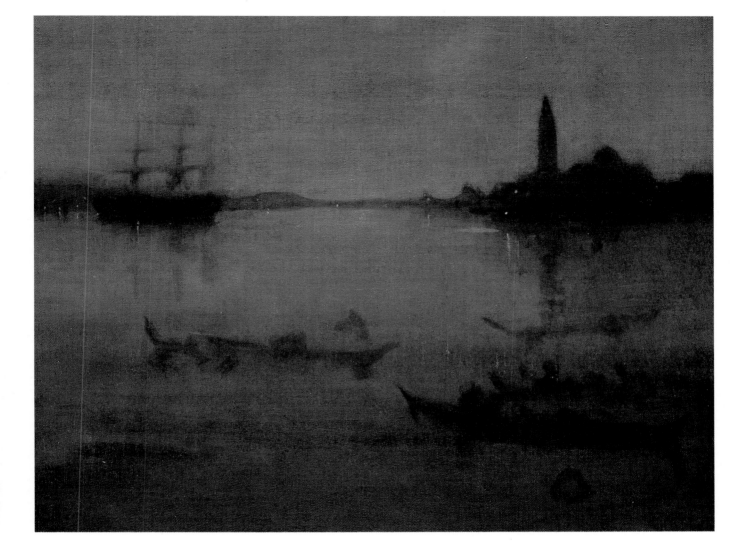

The Lagoon, Venice: Nocturne in Blue and Silver

c. 1880, oil on canvas; 20 x 26 in. (50.8 x 66 cm).

Emily L. Ainsely Fund, Museum of Fine Arts, Boston.

Whistler captures the picturesque silhouettes of boats and
architecture on Venice's Grand Canal. The tower and domes
of St. Mark's are visible in the right background, while gondolas
are presented as shadowy forms in the foreground. Whistler
rubbed down the forms in this work to blur their shapes.

Whistler was undeterred by this result and lost
no time proclaiming it a victory over Ruskin.
However, his "win" in court did not jump-start his
career as he had hoped. Indeed, the proceedings
set him back financially. When the judge pro-
nounced that the costs of the trial were to be split
evenly between the two parties, Whistler was left
with an expense he could not meet. His financial
situation soon became even worse. Although his
White House had established a new kind of eco-
nomical home design, its costs had arisen beyond
Whistler's expectations, saddling him with more
debt. Additionally, the buying public was more
reluctant than ever to take an interest in
Whistler's art. Instead of restoring Whistler's rep-
utation, the trial, with its uncomplimentary
result, made art patrons nervous.

With his debts mounting, Whistler was forced

into bankruptcy in May 1879. A meeting of his
creditors was held in June, and Leyland was the
most prominent of them. Whistler retaliated
against his former patron in three disdainful
works, including *The Gold Scab,* in which Leyland
is shown as a grotesque peacock playing the
piano. Later in June, Whistler was forced to auc-
tion the White House and its contents.

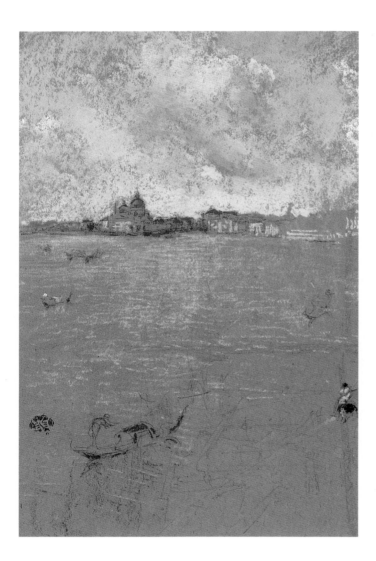

Venetian Scene

c. 1879, pastel, New Britain Museum of American Art, Connecticut.

In this view of a famous Venetian site, the Grand Canal with the domed Church of Santa Maria della Salute in the left distance, Whistler captured the drama of Venice with a highly minimalist treatment. He recorded floating, energetic qualities of the clouds with a soft rubbing of white chalk, while letting the beige tone of the paper remain exposed for the atmosphere, water, and architectural forms. Only a few dashes of blue and white suggest the structure of buildings.

A Year in Venice

To start rebuilding his life, Whistler came up with the idea of producing a series of etchings of Venice for the London Fine Arts Society. His proposal for twelve plates was accepted and he left for Venice with an advance of six hundred pounds in September of 1879. In Venice, Whistler stayed in cheap rooms where he struggled with the biting chill of the Venetian winter. Although he was supposed to complete his assignment in three months, he remained in Venice for a year and two months, creating both etchings for the Fine Arts Society and a group of pastels.

Instead of depicting the grand monuments of Venice that had been featured by Canaletto and Guardi, he portrayed the city's back alleys, painting its weathered, decaying palaces that stood along quiet canals. However, his real focus was on contrasts of shadow and light—the darkened entryways of buildings with light glistening through latticed awnings, and the sketchy outlines of buildings seen across the water. He used minimal lines, often just marks with his needle on a plate. To create his pastels, he carried his chalks with him, noting shifting qualities of light and delicate atmospheric effects at dusk and dawn with light-colored chalks on toned papers.

In Venice, Whistler came to know a community of American artists who were summering in the city, among them Frank Duveneck, Robert Blum, and Otto Bacher. These artists welcomed him into their midst and shared supplies and gossip with him. Many members of the American contingent were greatly influenced by Whistler's art, emulating his approach and spreading his influence in America.

Whistler returned to London in November of 1880, and the following month, he exhibited his etchings at the Fine Arts Society. Again his work received little appreciation from the critics or public, with the press still claiming that the prints were unfinished. When Whistler showed his Venetian pastels the following year, the critical response was the same, but the works attracted the attention of several individuals who bucked the popular trend by making purchases. Whistler humorously remarked to architect Edward

Godwin, "They are not as good as I supposed. They are selling!"

The buyers of Whistler's pastels may have been enticed by the setting in which the pastels were shown. Whistler had transformed the Fine Arts Society into an environment ideally suited to his works. The walls were painted yellow-gold and green-gold and the ceiling a reddish-brown. Placed in gold frames, the works were arranged mostly on a line so that their subtle individual qualities were accentuated.

The "Ten O'Clock Lecture"

Despite the success of his pastels, Whistler was unable to attract public notice to his art in the early 1880s, but during the decade he became the darling of a generation of younger artists, who lavished attention on him and sought to emulate him. Young artists of London contented themselves by being of even the slightest bit of assistance to Whistler. They derived pleasure from carrying out any menial tasks related to him or his work. Artists visiting from abroad, such as Americans William Merritt Chase and Julian Alden Weir, returned home with Whistler tales that became legendary. Gathering around Whistler, young artists absorbed knowledge of the master's techniques, soaked up his aura, and endured his egotism and criticism.

The loyalty of a follower, however, could be sorely tested. For example, Mortimer Menpes, an Australian artist who was a student of Whistler's, aroused his teacher's wrath when he traveled to Japan. Whistler considered the trip a slight, believing that Menpes should have been able to learn all he needed to know of the art of Japan from his teacher. Whistler decisively severed ties with Menpes when Menpes dared show his paintings at a London gallery without identifying himself as a "pupil of Whistler."

In 1881, Whistler made the acquaintance of the witty Irish-born writer Oscar Wilde, who would write *The Picture of Dorian Gray* in 1891. During the 1880s, the painter and author were often in each others' company. Their clever retorts to each other were commonly repeated in London magazines such as *Punch*. In one of their best known exchanges, Wilde proclaimed, "I wish I had

Ste. Giovani Apostolo et Evangelistae

1879–1880, pastel; 11 13/16 x 8 in. (29.6 x 20.3 cm).

Freer Gallery of Art, Washington, D.C.

Whistler explored the highly intricate decorative patterning on this building's facade by viewing it through a portal of another structure. Drawn with delicate lines and only a few dashes of color, the linear framework seems to take on a life of its own and produces a lively surface effect.

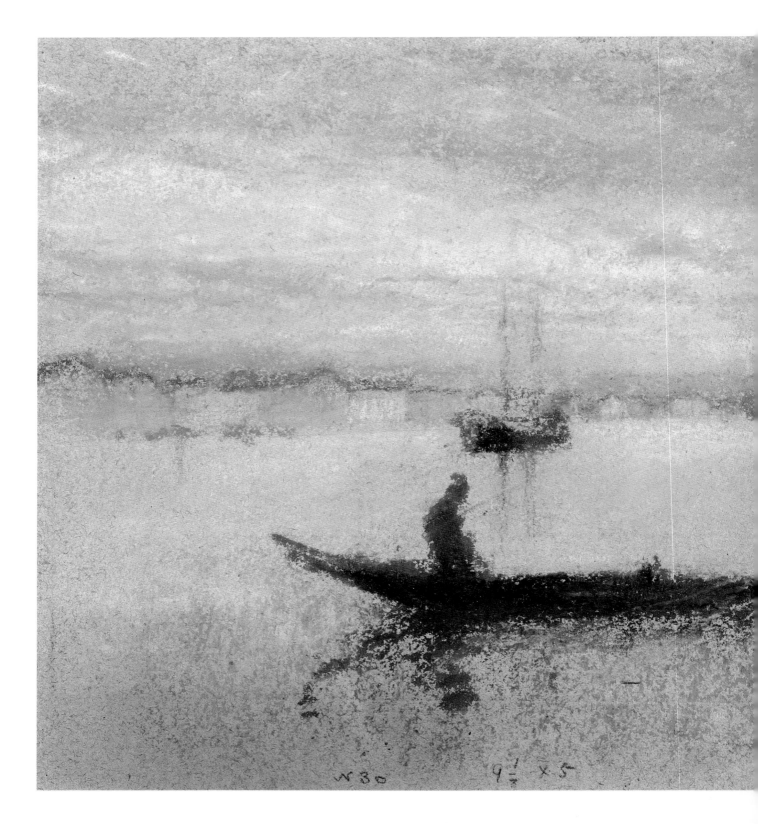

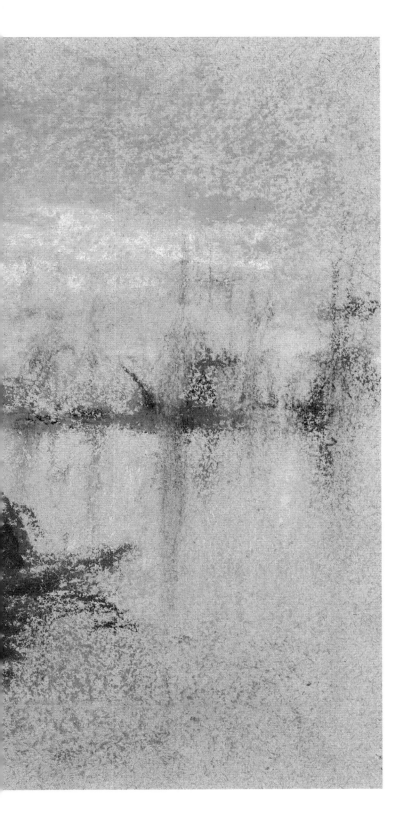

said that, Whistler," to which Whistler replied, "You will, Oscar, you will." This comment proved to be prophetic; increasingly Whistler found Wilde repeating statements at public gatherings that the artist had made as his own.

To retaliate, Whistler decided to hold a lecture for the public himself. His famous "Ten O'Clock Lecture" was held February 19, 1885 at Prince's Hall in London. Addressing a full hall, Whistler launched into a diatribe against the idea that art should have a purpose. He went on to proclaim that reproducing nature was not enough on its own to make art, that nature was a resource to be used by the artist. While some of his comments were heavy-handed, made in a preachy tone, the lecture's fresh prose and thought-provoking commentaries reflect the consistency of Whistler's ideas with his art.

The lecture was praised in contemporary newspapers. Among those who commented on it in print was Wilde, who called it a masterpiece "not merely for its clever satire and amusing jests . . . but for the pure and perfect beauty of many of its passages." At the end of his commentary, Wilde noted, "For that he is indeed one of the very greatest masters of painting, is my opinion. And I may add that in this opinion Mr. Whistler himself entirely concurs." Despite Wilde's words of praise, his final comment threw Whistler into a rage that led him to end his friendship with Wilde.

The Giudecca: Note in Flesh Colour

c. 1879, pastel; 5 x 9 in. (12.7 x 22.8 cm). Gift of George D. Pratt, Class of 1893, Mead Art Museum, Amherst, Massachusetts.
In this small pastel, Whistler conveyed the experience of looking across the Lagoon in Venice through mist and fog. The boats appear blurred in the dense atmosphere. The flesh color noted in the title is used as a subtle undertone rather than the dominant color, and its presence gives warmth to this otherwise cool image.

Four More Portraits

During the 1880s, Whistler finally began to sell his work, but the portrait commissions he sought in order to be assured of an income generally eluded him. A few members of society stepped up, however, to request works from him. One who did so was Sir Henry Meux, a brewer, who commissioned Whistler for three portraits of his wife Valerie. In the first, Whistler created an elegant

Arrangement in Black: Lady Meux

1881–1882, oil on canvas; 75 3/4 x 50 3/4 in.

(194.2 x 130.2 cm). Honolulu Academy of Arts, Hawaii.

This is the first of three portraits that Whistler created of Lady Valerie Meux. All three were commissioned by Henry Meux, the sitter's banker husband. Here, Lady Meux is dressed for the evening. Her long sumptuous fur shawl has a shimmering texture as a result of Whistler's method of painting with quick flecks of paint softly blended on canvas.

portrait that was a study in black with Lady Meux in a black gown, her form defined against the black background only by the soft white tone of her long fur shawl. The second featured pink and gray tones. Perhaps the most intriguing portrait that Whistler created in the 1880s depicted the art critic and journalist Théodore Duret. Whistler had been introduced to Duret by Manet in 1880, and Duret later wrote a monograph and a number of articles about Whistler. Whistler chose to show Duret in evening clothes holding a lady's pink fan and shawl.

The combination was incongruous to Duret's friends, who knew him to be distinctly uninterested in the company of women. For Whistler, the pink tones were needed, however, for the sake of the arrangement. While the background is painted gray, the pink tones of the clothing and fan seem to give it a pink glow. When Duret showed the portrait to friends, he suggested that they observe its background through a piece of cardboard, which verified that the wall was, in fact, not painted pink.

Marriage and Recognition

In 1888, Whistler gave up his long bachelorhood and surprised everyone, himself included, by suddenly marrying Beatrice Godwin, the widow of the architect who had designed the White House. The decision to marry Godwin, who had been a former student and a member of Whistler's social circle, came about during a dinner party when a friend proposed that the two wed. Both agreed on the spot, and they were married within a matter of days.

Despite the rapidity of the engagement, the marriage was successful and happy. Trixie made life easier for Whistler than it had been previously by resolving his discord with friends and helping him find portrait commissions. Whistler began to become financially successful. His works were selling, and his achievement was acknowledged when his portrait of Carlyle was purchased by the city of Glasgow and his painting of his mother was acquired by the French government for the Luxembourg Museum.

While his art was gaining recognition, Whistler was also becoming increasingly well known for his letters, which were often published in

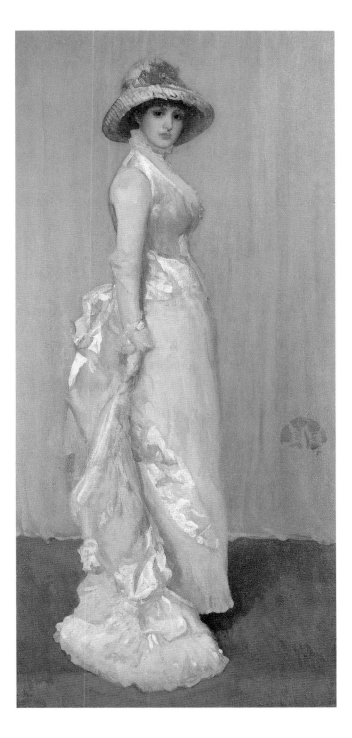

Harmony in Pink and Grey:
Portrait of Lady Meux

1881–1882, oil on canvas; 75.5 x 36 1/4 in.
(193.7 x 93 cm). The Frick Collection, New York.

This is the second in a series of three portraits of Lady Valerie Meux which were commissioned by her banker husband, Henry Meux. Wearing a dress with a long train of satin and lace and a high lace collar, the subject has an elegant bearing that is somewhat undercut by her large hat.

Arrangement in Flesh Color and Black:
Portrait of Théodore Duret

1883–1884, oil on canvas; (76 1/8 x 35 3/4 in.
(193.4 x 90.8 cm). Wolfe Fund, Catharine Lorillard Wolfe
Collection, The Metropolitan Museum of Art, New York.

Critic Théodore Duret was not a ladies man, and Whistler's decision to portray him with a woman's pink cloak and red fan gives this work an incongruous quality. Although Whistler claimed that he included the cloak and fan for purposes of his arrangement, these elements add a psychological dimension to the image. Duret's dour and perplexed expression suggests his discomfort at being thrust into a role that did not suit him.

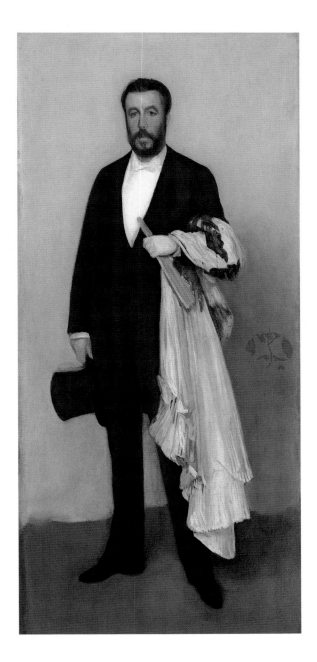

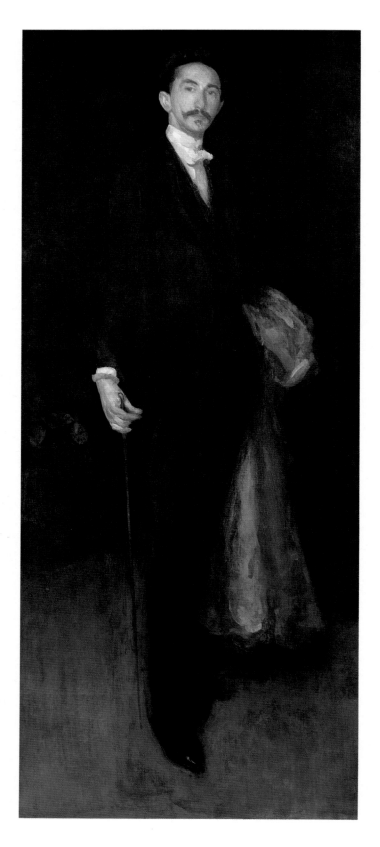

London newspapers. Realizing the popularity of Whistler's writings, Sheridan Ford, an American journalist who was living in London, proposed that they be compiled in a book. Whistler agreed, but when the book was about to be published, he changed his mind and decided to back out of his agreement. Since Whistler possessed the rights to his writings, Ford was forced to back away.

Acting as his own agent, Whistler went about having the book produced with the publisher William Heinemann. Heinemann found working with Whistler as grueling as had the artist's portrait subjects. The artist involved himself in every detail of the process, choosing the type, designing the layout, and drawing capricious butterflies for each entry. The book finally came out in 1890 on the tail of a series of pirated versions. Its contents included Whistler's edited version of the Ruskin trial, his "Ten O'Clock Lecture," comments from critics on Whistler's art, and other writings from catalogues, newspapers, and interviews.

A Return to Paris

In 1892, Whistler suddenly left London with Trixie and settled in Paris. The couple rented a garden apartment on the Left Bank in the rue du Bac, and Whistler established a studio at the top of a tall building in the rue Notre-Dame-des-Champs, which he decorated in tones of rose.

Despite his notoriety across the channel, Whistler's arrival in Paris caused little commo-

Arrangement in Black and Gold:
Comte Robert de Montesquiou-Fezensac

1891–1892, oil on canvas; 82 1/8 x 36 1/8 in.
(208.5 x 91.7 cm). The Frick Collection, New York.
Commissioned by the sitter, this painting depicts
a prominent Parisian dandy holding a chinchilla-
lined cloak over his arm. Montesquiou found
the cloak too heavy and became very tired while
posing. His languid stance suggests his fatigue.

tion. He developed friendships with leading artists including Claude Monet, Camille Pissarro, Puvis de Chavannes, Auguste Rodin, and Henri de Toulouse-Lautrec, and with writers such as Marcel Proust and the Symbolist poet Stéphane Mallarmé, who translated his "Ten O'Clock Lecture" into French.

Another friend of Whistler's in Paris was Count Robert de Montesquiou-Fezensac, an eccentric and exotic figure who claimed a rich aristocratic heritage and engaged in a hedonistic lifestyle. Whistler painted Montesquiou in a work entitled *Arrangement in Black and Gold*, in which the count's role as a dandy comes across in his languid pose, aloof gaze, gloved hand loosely holding the top of his cane, and his lithe build, which seems to dematerialize into the work's black background.

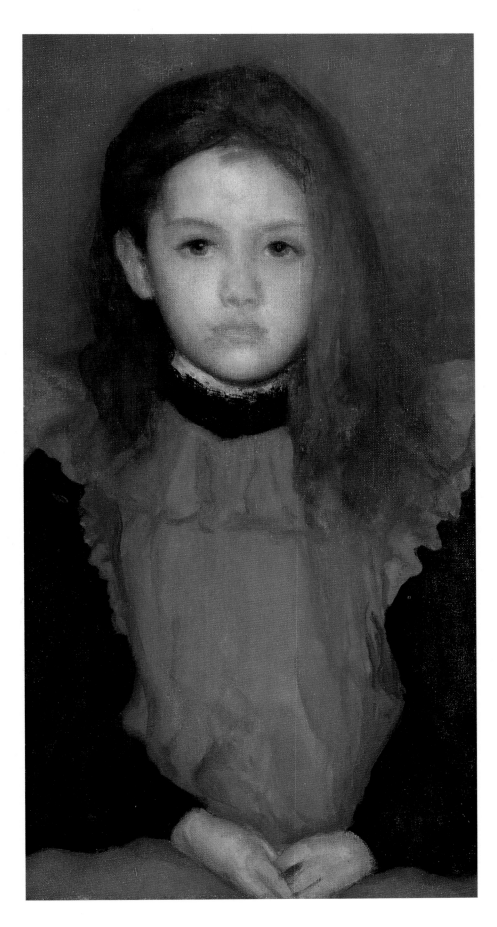

The Little Rose of Lyme Regis

1895, oil on canvas; 20 1/4 x 12 1/4 in.
(51.4 x 31.1 cm). William Wilkins Warren
Fund, Museum of Fine Arts, Boston.
Whistler told Joseph Pennell that this was one of his paintings in which "he had really solved the problem of carrying on his work as he wished to until it was finished." He made few changes to the painting, with the exception of the outline of the young girl's hair. In this fresh image of youth, the subject appears charmingly real while the tonal arrangement is highly pleasing.

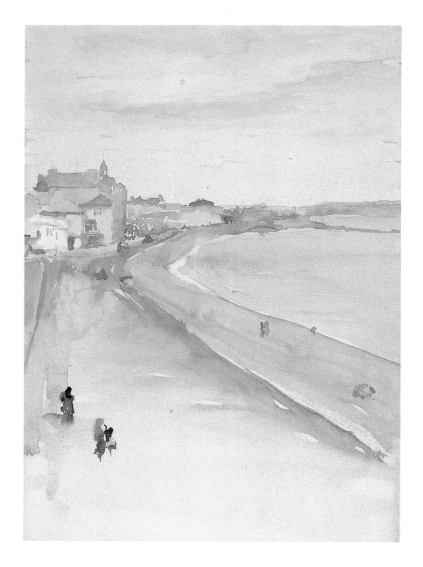

St. Ives, Cornwall

1883, watercolor; 6 7/8 x 4 15/16 in. (17.6 x 12.6 cm).

Freer Gallery of Art, Washington, D.C.

Whistler used very light washes to suggest the soft
texture of a sandy beach in which a diffused atmospheric
light is reflected. The open space in the foreground
and the long, broad curve of the beach give this scene
a feeling of quietude that is also emphasized by the
occasional dashes of color indicating strolling figures.

By the Sea

In 1894, Whistler was at the top of his career and happily receiving commissions when bad news struck. Trixie was diagnosed with cancer. The couple considered going to America for treatment, but changed their minds when they learned that the cancer was not curable. Instead of surgery, they opted for a stay at the coast at Lyme Regis in Dorsetshire, England, where Whistler painted *The Little Rose of Lyme Regis*.

Whistler loved children and painted many of them during the last decade of his career. His depictions portray subjects who are pensive, their thoughts kept from the viewer. In *The Little Rose*, the subject is shown in a fluffy pinafore suggestive of her young age, but her serious and reflective expression reveals a wisdom beyond her years.

During his late career, Whistler returned to the seascape subject he had painted in the 1860s, but the scale of his works became smaller and his compositions became more spare. Instead of focusing on tonal values as in his nocturnes of the 1870s, he explored color, using strong contrasts of blue, pink, green, and ochre, with brown and black employed to provide accents. Dividing his compositions into horizontal bands of color representing beach, sea, and sky, with just a few touches to note figures or boats, Whistler explored minimalist composition, letting succinct brush strokes capture the dynamism of his elemental forms. With just a few strokes, he expressed the smoothness of sand, the force of waves, and the weight of breaking clouds.

The Final Years

In May 1896, Trixie passed away at Hampstead Heath, outside London, where Whistler had rented a cottage. In his grief, Whistler went to live in London with William Heinemann. Two years later, he returned to Paris, where he established the Académie Whistler, which was operated by a former model, Carmen Rossi. The American sculptor Frederick MacMonnies signed on to assist at the school. When Whistler gradually distanced himself from the school due to poor health, students were disappointed by his absence and eventually enrollment dropped. The school was closed in 1901.

In his last years, Whistler's health declined, but he worked intermittently and maintained important friendships such as that with Charles Lang Freer, a manufacturer of railroad cars. Freer became the most significant individual collector of Whistler's works, and today the Freer Gallery houses the largest group of works by Whistler. Among Freer's acquisitions was Whistler's Peacock Room, which is today installed almost as it had been in London in The Freer Gallery of Art, Washington, D.C., although without Leyland's blue-and-white china.

In August 1902, Whistler had a heart attack while visiting The Hague with Freer. To Whistler's amusement, an article that sounded like an obituary appeared in a London newspaper. Whistler sent a response to the paper acknowledging "the tender little glow of health induced by reading . . . the flattering attention paid me by your gentleman." However, within the year that followed, his health deteriorated further, and the next July, while at home in London at Cheyne Walk, another heart attack struck which turned out to be fatal. His funeral was held at a church on the waterfront in Old Chelsea, and he was buried next to his wife in a little churchyard overlooking the Thames.

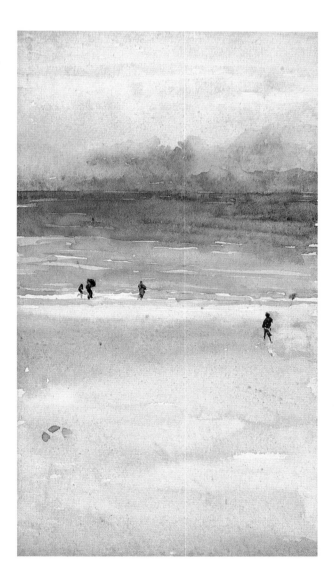

Sea and Sand: Domburg

1900, watercolor; 8 1/2 x 5 1/16 in.

(21.5 x 12.8 cm). Hunterian Art Gallery, Glasgow.

Whistler wrote to Joseph Pennell in August of 1900, noting that "he found Domburg a wonderful little place, just beginning to be known but not yet exploited, and he recommends a visit before it is ruined." He captures the freshness of this coastal site with delicate washes of lavender, blue, and creamy beige.

The Staircase: Note in Red

1879–1880, pastel; 11 5/16 x 8 in. (29.6 x 20.3 cm). Freer Gallery of Art, Washington, D.C.
In this bright pastel, the red-orange tone in the stairway makes the
beige paper appear reddish in tone, while additional red notes are seen
in the window's shutters together with the artist's signature butterfly,
which appears like a mark of graffiti on the wall at the right.

Fishing Boats

c. 1879, pastel; 11 5/8 x 7 15/16 in. (29.5. x 20.1 cm). Cincinnati Art Museum, Ohio.
Although a boat with yellow and black sails is the principal motif in this work,
the presence of other boats guides the viewer in a circular fashion through
the composition. Light rubbings of pale blue, yellow, and white convey
the smooth reflective surface of the water and the broken clouds in the sky.

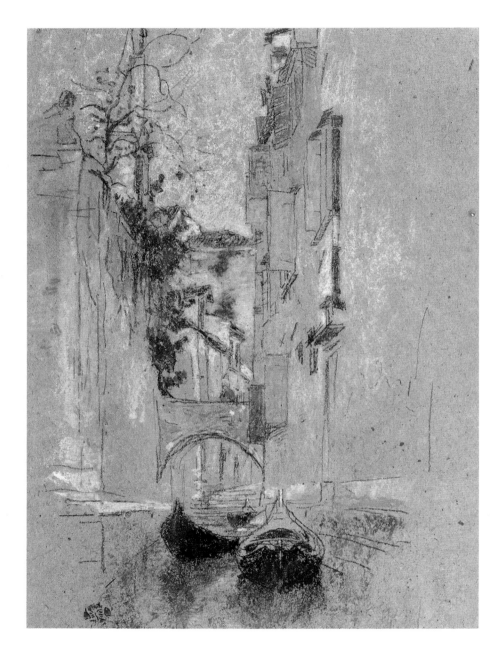

The Little Back Canal

c. 1879, pastel; 11 13/16 x 8 in. (29.6 x 20.3 cm). The Frick Collection, New York.

Choosing a vertical format for this pastel, Whistler accentuated the
narrowness of a quiet Venetian canal. The thin, unbroken lines he
used to depict architectural facades further reveal his delight in the
graceful forms of the tall structures that close in the slender waterway.

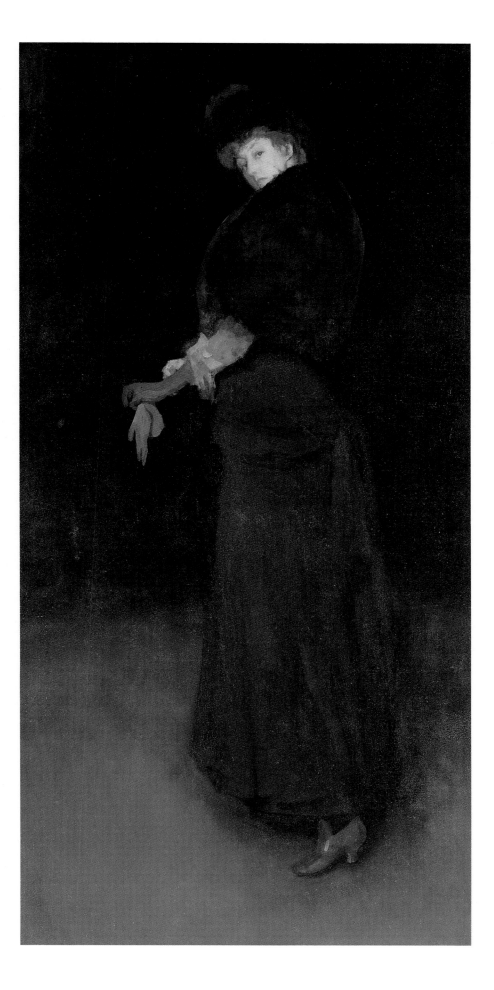

**Arrangement in Black:
The Lady in the Yellow
Buskin—Portrait of Lady
Archibald Campbell**

1882–1884, oil on canvas;

86 x 43 1/2 in. (213.3 x 109.2 cm).

W. P. Wilstach Collection,

The Philadelphia Museum of Art.

Whistler painted his sitter in the
dress she wore to visit him, and
he was so pleased with this image
of a woman in brown boots, brown
leather gloves, and a fur wrap that
he sent it to Paris for exhibition at
the Paris Salon. The Campbell fami-
ly chose not to purchase the por-
trait, commenting that it showed
a "street walker encouraging a shy
follower with a backward glance."

The Sea Shore

1883–1885, watercolor; 8 3/8 x 5 in. (21.5 x 12.8 cm).
Freer Gallery of Art, Washington, D.C.
Although dividing his composition into
three registers, Whistler created a harmonious
arrangement by reiterating the same tones
of pale gray, gray-beige, and light blue
throughout the work. The dot of red
indicating the parasol of a figure on the
beach is repeated in a sailboat on the horizon.

Pink Note—The Novelette

c. 1883–1884, watercolor; 10 1/10 x 6 1/5 in.
(25.3 x 15.5 cm). Freer Gallery of Art, Washington, D.C.
In this view of his red-haired mistress, Maud Franklin,
Whistler creates an arrangement in which the figure
and the rumpled bed on which she sits are integrat-
ed into a pattern of varied colors and unified by a
soft gray light. Whistler handles the loose clothing
on the bed with delicate gestural strokes of gray
and ocher, while one item in the foreground is com-
posed by leaving an area of bare paper exposed.

Moreby Hall

1883–1884, watercolor; 7 1/2 x 11 in.

(19. 5 x 28.3 cm). Freer Gallery of Art, Washington, D.C.

Built in the Tudor-Elizabethan style, the house whose
interior is seen here was a typical Victorian country
dwelling. Whistler chose to feature the roaring fireplace,
porcelain plates on the mantle, and dark Old-Master-
style paintings lining the walls, capturing the elements
that he perhaps found most appealing in the residence.

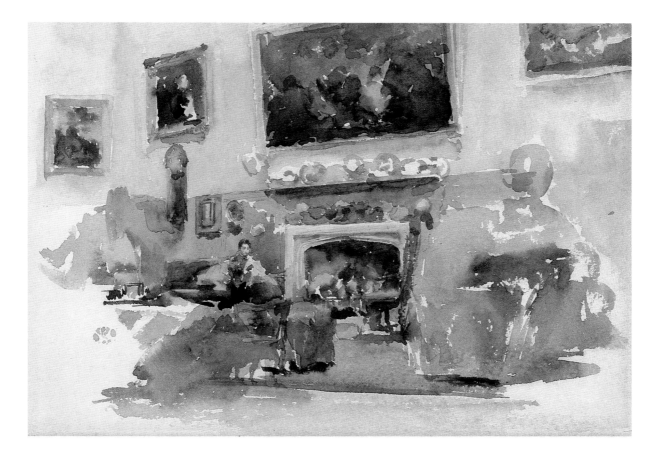

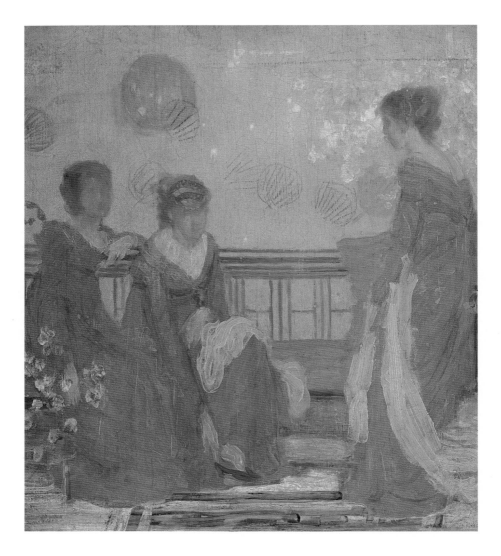

Red and Black

1883–1884, watercolor; 9 1/2 x 5 1/8 in. (24.1 x 13 cm).

Emily L. Ainsley Fund, Fogg Art Museum, Harvard University.

In this watercolor, Whistler depicted the actress Kate Munro
wearing a black robe and flouncy skirt and standing before
a curtain. Munro was both notorious for her clever acting as
well as for supposedly bearing two children with a royal figure.

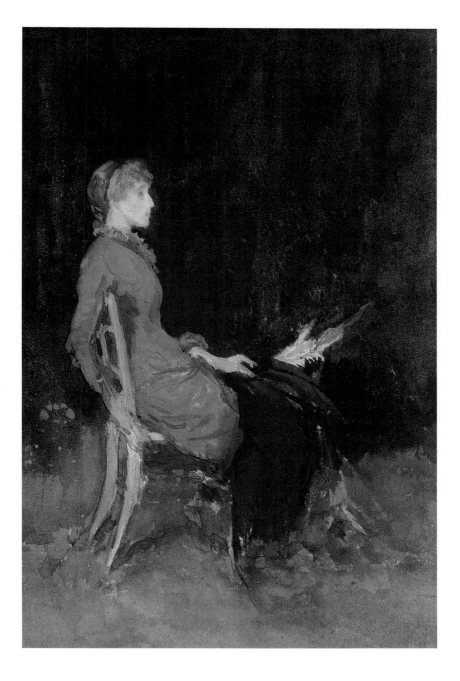

Study in Black and Red (Madge O'Donoghue)

1883–1884, watercolor; 9 x 6 1/4 in. (228 x 159 cm). Gift of Mr. And Mrs. Paul Mellon, in honor of the 50th Anniversary of the National Gallery of Art, The National Gallery of Art, Washington, D.C.

Whistler uses watercolor effectively in this image of a young attractive woman. The soft mauve tone of the sitter's dress and her creamy complexion sparkle against the dark background. A black cloak slung over the subject's lap links the figure with her surroundings.

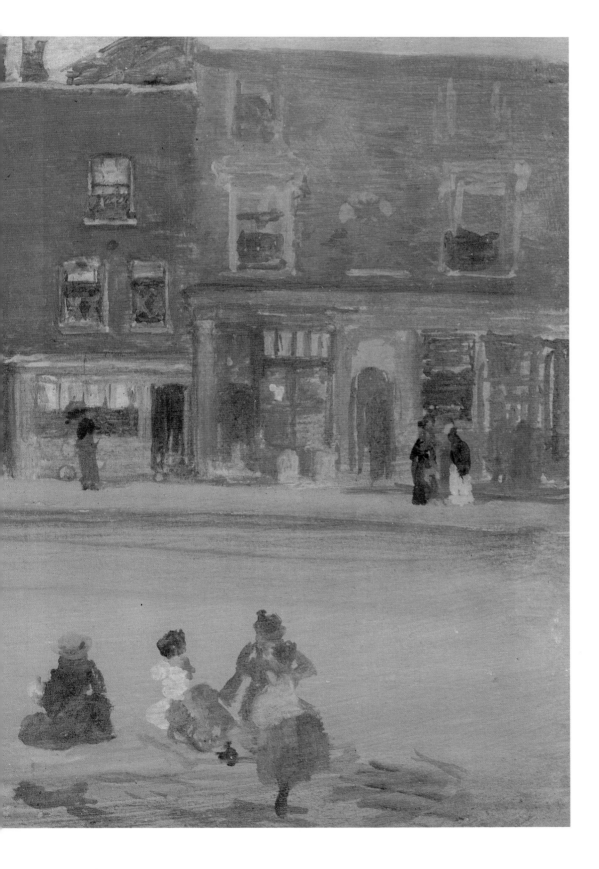

Street in Old Chelsea

1880–1885, oil on panel;
5 1/4 x 9 in. (13.3 x 23.3 cm).
Gift of Denman Waldo Ross,
Museum of Fine Arts, Boston.
Whistler painted his image
of the shops of London's
Chelsea neighborhood
with small brushes, using
a detailed approach that
he usually avoided.
Whereas he generally
painted this type of sub-
ject at dusk and night, in
a rare daylight view he
captures the charm of this
neighborhood of low-rise
buildings with their varied
and colorful facades.

An Orange Note: Sweet Shop

1884, oil on panel; 5 x 8 /14 in. (12.2 x 21.5 cm). Freer Gallery of Art, Washington, D.C.
The walls of a storefront provided Whistler with an opportunity to treat a picture as a flat composition without denying rules of perspective. In this work, he used impasto to indicate the stuccoed texture of the walls, bringing out their peach undertone with the "orange note" of fruits or flowers in a window.

Chelsea Shops

early 1880s, oil on canvas; 5 1/4 x 9 1/8 in. (13.5 x 23.4 cm). Freer Gallery of Art, Washington, D.C.
This may be Whistler's earliest view of storefronts. The canvas is divided into geometric sections, within which space is further broken down into angular forms. Whistler's interest reducing the picture plane into mathematical units reveals a concern with symmetry and abstraction that would be taken up again by twentieth-century geometric abstractionists.

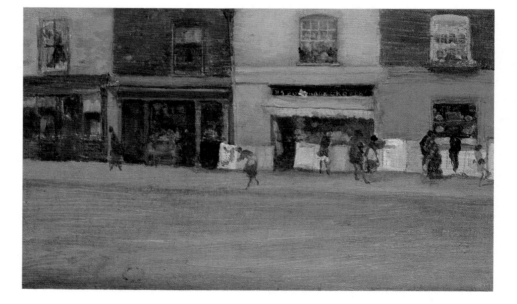

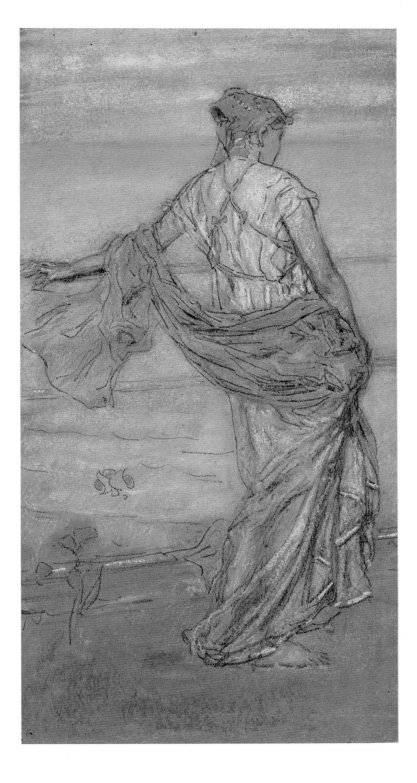

Annabel Lee

1885–1887, pastel; 12 3/4 x 7 1/16 in.
(32.3 x 17.9 cm). Freer Gallery
of Art, Washington, D.C.
This pastel has been associated
with Edgar Allan Poe's poem
"Annabel Lee," in which the
poet memorialized his wife,
who had died at a young age.
Wearing a semi-classical robe
and swaying in rhythm, her shawl
flowing behind her, the subject is
presented as mysterious and wist-
fully sad as she gazes out to sea.

Rose and Silver: Portrait of Mrs. Whibley

1894–1895, watercolor; 10 13/16 x 7 3/16 in.

(27.4 x 18.2 cm). Freer Gallery of Art, Washington, D.C.

Whistler portrays his sister-in-law, Ethel Birnie Philip,
who was his secretary and model in the early 1890s.
Showing Philip in a fashionable mauve hat and
gown and a long curving fur wrap, Whistler creates
an elegant arrangement in mauve and dark gray.

Mother of Pearl and Silver: The Andalusian

1888–1900, oil on canvas; 59 x 35 in.
(191.5 x 89.8 cm). Harris Whittemore Collection,
The National Gallery of Art, Washington, D.C.

In this portrait, Whistler depicted Ethel Philip, the younger sister of his wife Bertrice. Referring by its title "The Andalusion" to southern Spain, Whistler clearly intended the work as an homage to the great Spanish Baroque painter Velásquez, whose art he adored. The painting was begun in 1888, but not completed until the end of the century.

Rose et argent: La Jolie Mutine

c. 1890, oil on canvas; 74 1/4 x 34 7/8 in.
(190.5 x 89.5 cm). Hunterian Art Gallery, Glasgow.

In this portrait, Whistler shows a fashionable young woman whose identity is not known today. While the face of the sitter is finished, Whistler left the figure's hands in a sketchy state. Apparently, he had trouble deciding how to position them, as, originally, both were approximately an inch further to the left.

Lillie: An Oval

after 1896, oil on canvas; 23 1/2 x 19 in. (60.5 x 48.8 cm). Hunterian Art Gallery, Glasgow.

Whistler created several portraits of this subject, Lillie Pamington, a young
woman he met while taking a cab through an impoverished district of London
near his studio on Fitzroy street. When the girl's mother curled her hair for her
portrait with Whistler, the artist was horrified and asked that she be brought
in the way he had first seen her. Whistler created three known views of Lillie,
including this one, in which the oval format echoes the figure's oval-shaped face.

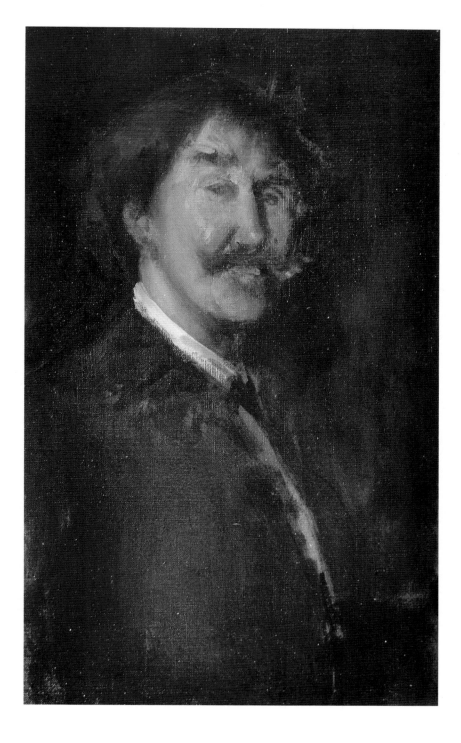

Portrait of the Artist

c. 1896, oil on canvas; 20 x 12 1/2 in. (51.5 x 31.8 cm). Hunterian Art Gallery, Glasgow.
Whistler created a number of self-portraits in the 1890s in which he
emerges from a shadowed background and glances over his shoulder.
These works suggest the artist's fascination with how subtle variations
in composition and tone emphasized different aspects of his personality.

INDEX